fresh & easy watercolors for beginners

Bonnie J. Frederico, CDA

NORTH LIGHT BOOKS
CINCINNATI, OHIO
www.artistsnetwork.com

Other fine North Light Books are available from your local bookstore, art supply store or direct from the publisher.

07 06 05 04 03 5 4 3 2 1

Library of Congress Cataloging-in-Publication Data
Frederico, Bonnie J.
 Fresh & easy watercolors for beginners /
 Bonnie J. Frederico.-- 1st ed.
 p. cm.
 Includes index
 ISBN 1-58180-412-1 (pbk. : alk. paper)
 1. Watercolor painting--Technique. I. Title: Fresh and easy watercolors for beginners.
II. Title.

ND2420.F73 2004
751.42'2--dc22 2003058073

Editor: Holly Davis
Production Coordinator: Kristen Heller
Designer: Marissa Bowers
Page Designer: Kathy Gardner
Photographers: Christine Polomsky and Tim Grondin

Metric Conversion Chart

TO CONVERT	TO	MULTIPLY BY
Inches	Centimeters	2.54
Centimeters	Inches	0.4
Feet	Centimeters	30.5
Centimeters	Feet	0.03
Yards	Meters	0.9
Meters	Yards	1.1
Sq. Inches	Sq. Centimeters	6.45
Sq. Centimeters	Sq. Inches	0.16
Sq. Feet	Sq. Meters	0.09
Sq. Meters	Sq. Feet	10.8
Sq. Yards	Sq. Meters	0.8
Sq. Meters	Sq. Yards	1.2
Pounds	Kilograms	0.45
Kilograms	Pounds	2.2
Ounces	Grams	28.3
Grams	Ounces	0.035

About the Author

Bonnie J. Frederico was born and raised in a beautiful New England town where she still lives with her husband, three married daughters and Winston, her dog. From early childhood she wanted to paint, even if just to help her family paint their home. As years passed, her enthusiasm didn't change.

Ironically, taking art classes in high school and college didn't send her on her way; instead she became a math teacher. Her ability to teach others led her into the decorative art field, and in 1994 she passed her CDA certification. Her love for watercolors began in classes taught by Sonja McKenzie. Bonnie's family especially enjoys her watercolors, encouraging her to paint scenes of her yard and around town.

Besides the classes she conducts from her home, Bonnie teaches at conventions in the United States and Canada. She was the convention artist for New England Traditions 2001. Bonnie has written over fifty painting packets as well as articles for *The Decorative Painter*, *Tole World* and *Crafts* magazine.

You can find more information about Bonnie J. Frederico at www.Sellarshop.com, or you can contact her at bonnief@infionline.net.

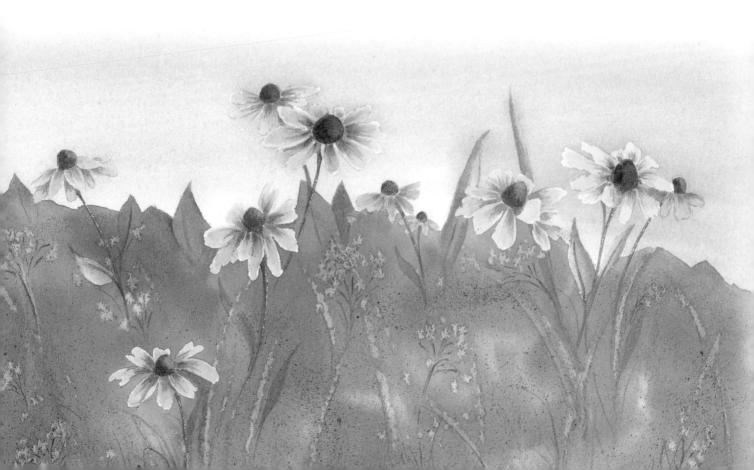

Dedication

I want to dedicate this book to my family: my husband, Tom, and my daughters, Tammi, Tracy and

Beth, who have supported me through all my endeavors.

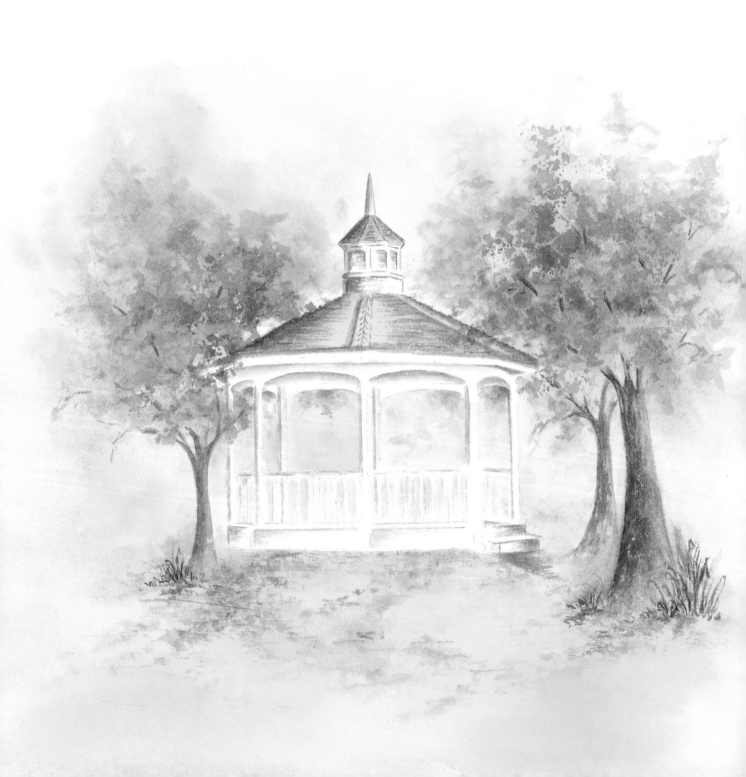

Acknowledgments

There are so many people to acknowledge. First my family,

for allowing me the opportunity to follow my dream—my love

of painting.

Then my friends and teachers for their encouragement to go

beyond and do the unexpected. Also my traveling companions,

who have challenged me to expand my horizons.

Many thanks to my students, who have helped me grow and

whose lives I, in turn, helped to enrich with a love of painting.

My students make me who I am, and I will be forever grateful.

A special thank-you to Kathy Kipp at North Light Books for

stopping by my booth and having faith in me to write this book.

Also to my editor, Holly Davis, and my photographer Christine

Polomsky, for making my photoshoot at North Light Books an

enjoyable experience. I am grateful to all those I met at North

Light who have had input into my book.

Table of Contents

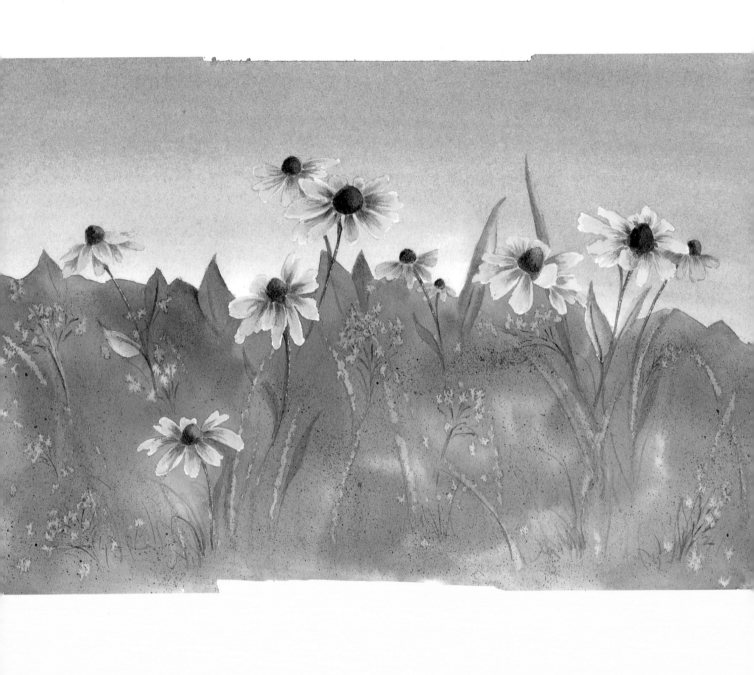

Introduction

Follow your creative impulse! With only a small investment of your time and money, you'll be on your way, exploring the world of watercolor painting. By starting with these beginner projects, you'll be able to conquer some of the easier techniques and feel successful creating paintings and crafted items to enjoy for yourself or to give to others.

As you work through this book, you'll see that many of the projects originate from things familiar to me—a scene from my town, a simple flower or apples fallen from my tree. I find ideas everywhere, as will you. Soon you'll be able to take what you've learned here, apply your own creativity, and come up with your own project ideas. What's more, you'll feel confident to move on to more difficult paintings.

Wishing you many colorful creations,

Bonnie J. Frederico

Brushes

Materials

The right brush for the job makes all the difference in the world, but the right brush for you might not be the right one for your friend. Experiment and get to know your brushes. Breaking them in will take some time, so be patient.

The brushes that I list in this book are the ones appropriate for the projects as I painted them. If your goal is to paint larger pictures, the brushes need to be larger.

Brushes come in three types. Sable, a natural fiber, is the most expensive and is known for its ability to carry large amounts of water and paint. Synthetic brushes are man-made and, usually, the least expensive. Sable/synthetic brushes are a combination of the two fibers. There are several good brushes on the market, and the most important thing (as with all your materials) is knowing what your brushes will do. The brushes I used for this book are synthetic.

As you will see in my list of brushes at the beginning of each project, I recommend the Royal Majestic brand, but in the project photos you may notice that my no. 6 round is a Susan Scheewe. I was introduced to this brush in a class and really loved its size and performance. I've continued to use it ever since. This is what I mean when I say that you need to be comfortable with your materials and know how they react.

A good starter set of brushes is a no. 1 liner; nos. 2, 4, 6, and 8 rounds; and a 1-inch (25mm) flat wash (also called a flat). The liner and rounds must come to a good point and hold that point while you work. The flat is used for dampening the paper and applying washes. Preferably, the flat will have a beveled handle, which is used for special techniques (see page 32). In this book, the no. 2 round is used only to apply masking fluid. I recommend using an old, but well-formed, brush for this.

Take good care of your brushes. They will last for many years if you do. Rinse your brushes throughout your painting session, but never leave them sitting in water. At the end of the painting day, give all your brushes a good cleaning. Rinse them well in warm water and mild soap, if needed, until there is no pigment left in the brushes. Reshape and dry. Finally, store them in a container with their tips up for protection.

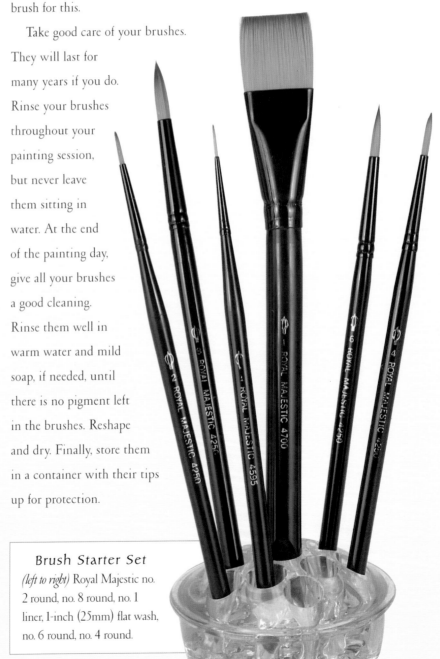

Brush Starter Set
(left to right) Royal Majestic no. 2 round, no. 8 round, no. 1 liner, 1-inch (25mm) flat wash, no. 6 round, no. 4 round.

Paint

Professional-grade paint is naturally more expensive than student-grade paint, but it's definitely worth the additional money. Professional paints have a higher percentage of pure pigment in every tube, which makes your paintings more vibrant! As a beginner, you may need to cut costs. Start off with a few tubes of professional-grade paint in primary colors. As you experiment, add warm and cool colors of each as your budget allows. For this book, I used Winsor & Newton Artists' Water Colours.

There are many other things to consider when you're buying your first tubes of paint. You may encounter words such as transparent, semi-transparent, opaque, lifting, staining, granulating and gouache.

Transparent refers to a see-through quality. Light passes through the paint, hits the paper and bounces back for the viewer to see. Consequently, you hear people speak of the luminosity of the painting.

Opaque paint does not allow for light to pass through and may create a muddy painting if not handled correctly.

Semi-transparent paint falls somewhere between transparent and opaque.

Lifting and staining have to do with whether or not the pigment can be removed from the paper. If a lifting or nonstaining color is applied to the paper, the majority of the pigment may be removed. A staining pigment would not be removable, but would soak into the fiber of the paper.

Granulating is a process that occurs when certain colors are mixed together, creating small, but visible, pieces of sediment. Depending on the painting, this may or may not be something you want to happen.

Gouache is an opaque watercolor. It can be used to provide striking accents or mixed with your other watercolors for interesting effects and greater opacity.

The paints you purchase may vary from brand to brand, depending on how the manufacturer chooses to make them. These differences will occur due to the amount of pigment, binders (what holds the paint together) and fillers that have been added, with the most important being the pigment. Choose wisely.

Mediums

Winsor & Newton Art Masking Fluid is used on several projects in this book. This is a liquid latex made up of latex, water, ammonia and, usually, a color. Other names you may encounter are miskit, frisket, maskoid or drawing gum, depending on the manufacturer. Each serves the same purpose—preserving, or masking, the white of the paper as you paint over it. As with all products, find one masking fluid that suits your needs and become familiar with it.

Iridescent mediums can be used to give your paintings a shimmery effect as seen in the snow scene (see page 91). It can be applied directly to the painting or mixed with your watercolors.

Glitter paints are found and used mainly in the craft market. The paint consists of small pieces of metal submerged in a clear binder. When applied to the paper, it creates a sparkle (see autumn leaf pin, page 41).

Palette

If you're a beginner, you may want to keep the cost of your palette to a minimum. If you're a crafter, you may already own a pad of acrylic palette paper, which is fine for getting started in watercolors. A clean Styrofoam grocer's tray would also suffice. If you have neither of these, you might find a white butcher's tray at a flea market or use a piece of Plexiglas over a white sheet of paper.

As you progress you may feel that you would like something more professional. Look for a palette with wells around the outside edge and a nice large mixing area in the center. Preferably, get a palette with a cover, which helps keep dust off the paint between painting sessions and also is convenient when you need to transport your colors. Actually, less paint is wasted with a more professional palette. Most paint will last for an indefinite length of time, only needing to be spritzed with a water bottle to bring it back to life.

Be consistent when setting up your palette. Put warm colors on one side and cool on the other. You'll find it helpful to identify the names of the paint on the outside edge of the palette with a permanent black marker (which can be removed with nail polish remover, if necessary). However you set up your palette, a consistent method assures that you'll always know where your colors are located.

A clean Styrofoam meat tray or a pad of acrylic palette paper make good inexpensive watercolor palettes.

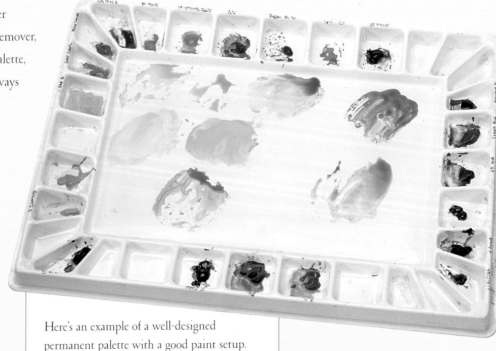

Here's an example of a well-designed permanent palette with a good paint setup.

Paper

Arches Paper has been made since the time of Christopher Columbus. The type of Arches paper I used in these projects originated in France in 1557. At that time it was made from cotton rags and pure stream water. Now it is similarly made from natural cotton fibers and water. Sometimes when I'm teaching a class and everyone is wetting down their paper, we'll smell dirty wet socks. That's just the smell of the wet cotton fiber coming through.

Paper can be handmade, mould-made or machine-made. Handmade paper, as you would expect, is very expensive. I painted the projects in this book on mould-made paper, 22" x 30" (55.9cm x 76.2cm), cut to the necessary size. This minimizes waste. Machine-made paper is usually found in pads. This paper will not take the abuse that a mould-made paper will, no matter what the weight.

Even though your paper may be made with 100 percent cotton fiber, you need to be sure that the paper is acid free. If it is not acid free, the paper will yellow and deteriorate with time. Even the acidity in your hands can damage the paper, so try to hold the paper by its edges.

Watercolor paper is coated (sized) with gelatine. This helps the paint pigment absorb in the right amount. It also keeps masking fluid from damaging the surface and eases the lifting of color.

Watercolor paper can be found in both bright white and natural white. I painted all the projects in this book on natural white, but either would be fine.

When buying paper, you must consider different surfaces, such as smooth, slightly textured or more textured. Smooth paper is referred to as hot-pressed. Glazing (see page 25) is more difficult on this paper because of its low absorption. Slightly textured paper, called cold-pressed, is the most commonly used. It's much easier to glaze this paper because of its higher absorption level. The most textured paper, called rough, has the highest level of absorption, which makes lifting color difficult.

Not only do you need to consider the surface of the paper, but you also need to consider its weight. The weight or thickness is based on a ream of 500 sheets of paper. The most common weights are 90-lb. (190gsm), 140-lb. (300gsm) and 300-lb.

(640gsm). The heavier the sheet, the less it will buckle when saturated with water. It will also be more expensive. Cold-pressed 140-lb. (300gsm.) paper is most commonly used.

You will find a watermark in the lower right-hand corner of your paper. This is the trademark of the company that makes it. If you can read the mark, you're looking at the right side of the paper—the preferred side on which to paint. However, it's perfectly fine to paint on the reverse side as well.

Remember that each paper manufacturer has its own characteristics. My advice is to buy the best paper you can afford, and, as with your other supplies, get to know what it can do.

Bonnie's Paper Preferences

Here's a quick list of my paper recommendations for projects in this book:

- Arches brand

- mould-made

- 22" x 30" (55.9cm x 76.2cm), cut to size

- Acid-free

- Either bright white or natural white

- Cold-pressed

- 140-lb. (300gsm) or 300-lb. (640gsm), depending on the project

Other Common Supplies

The following commonly used items will round out your painting supplies:

Foamcore Used to mount your watercolor paper (see page 16). Other choices are Plexiglas, plywood or Masonite, but none of these is as light as foamcore.

Con-Tact paper Used to cover your painting board, assuming it's not already impervious to water.

Scotch Safe-Release Painters' Masking Tape Holds your watercolor paper to the painting board. It can also be used for masking effects (as it is with the trellis in the Morning Glories project, pages 66-73).

Pencil or stylus Used to transfer your pattern to the watercolor paper. The stylus gives a more precise transfer, but you must be careful that the pressure you apply doesn't score the paper. Of course, a pencil is also handy for jotting notes, touching up pattern lines or adding markings.

Tracing paper Clear, transparent paper used to copy the original design. Generally, you will transfer your design from a tracing-paper copy.

Transfer paper Used to transfer a pattern onto watercolor paper. I prefer the Saral brand because it's wax free.

Light box Another means of transferring your pattern. A light box is just what it sounds like—a box with a light inside. The top of the box is glass, letting the light shine through. A sunny window can act as an inexpensive light box. (See page 19.)

Ruler Used as a straightedge or for measurements.

Scissors Different types and sizes are used for different jobs. The poinsettia bag (see pages 42-55) uses one pair for simple straight cutting of the box flaps and another pair to create a decorative edge.

Water containers Margarine tubs or other small plastic containers to hold water for rinsing brushes or adding water to paints. The sizes you need will depend on the brushes you use.

Paper towels/roll of toilet paper Used for wiping brushes and removing excess moisture from the watercolor paper.

Cotton swabs Used to wipe away excess moisture and color and to create special effects.

Soap Preferably nonperfumed. Worked into your brush to form a nice point for masking.

Rubber cement eraser Used to remove masking fluid.

Plastic eraser Extrasoft white eraser for gentle erasing on watercolor paper. It won't lift off color or ink lines.

Beveled-handle brush May be found on rounds or flats, depending on the manufacturer. The handle is used for special painting techniques (see page 32).

Craft knife or X-Acto Used for painting touch-ups and special effects.

Hair dryer Speeds up drying time.

A Few Extras

These household items may not seem like painters' tools, but they're used in this book for special effects. Buy them as you need them. Chances are, you'll think of more ways to use them in your paintings.

Spring clothespin Used as a holding and squeezing tool to form the paper (see forming of autumn leaf pin, page 39).

Salt Creates a delicate mottling (see page 28).

Sponge Creates mottled look often used for foliage (see page 29).

Toothbrush Used for speckling (see page 27).

Doily Used as a stencil to create a lacy look (see page 30).

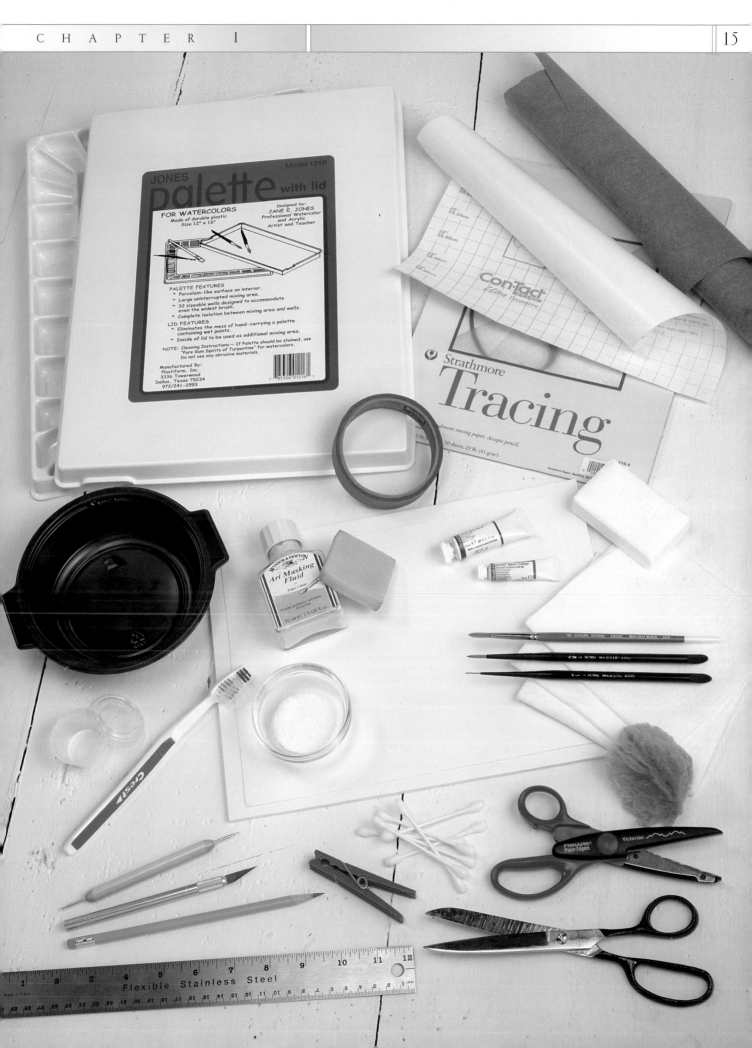

Preparing a Painting Board

You will generally need to attach your painting paper to a rigid surface. I recommend foamcore, but plywood, Masonite, glass or Plexiglas will do. You can also use cardboard as long as it isn't corrugated, because the corrugated ripples will show on your painting. The board should be a couple of inches longer and wider than your painting paper.

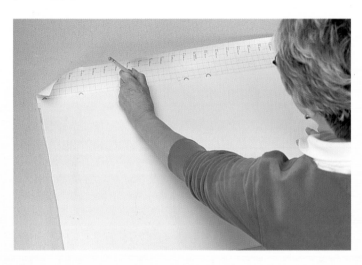

1 If your board isn't impervious to water, place it on Con-Tact paper, lining it up on the grid. Draw a pencil line on the contact paper around the edge of the board.

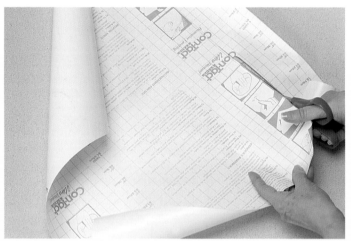

2 Cut the Con-Tact paper on the pencil lines.

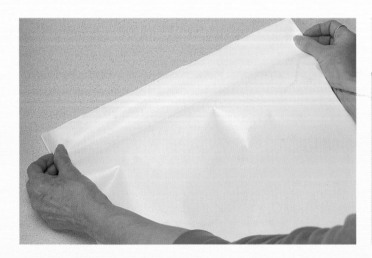

3 Peel one edge of the backing off the Con-Tact paper and line up the sticky edge to the edge of your painting board. Press the Con-Tact paper firmly in place.

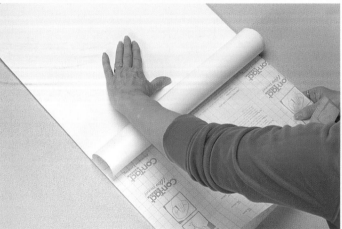

4 Pull off the Con-Tact paper backing a little at a time, pressing the paper down and working out the air bubbles.

Taping Down the Paper

Once your painting board is ready, you can attach the painting paper.

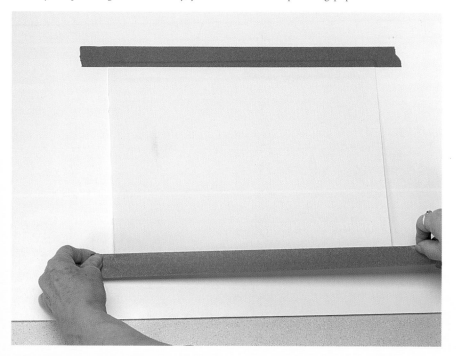

Cut your painting paper to the desired size, and place it in the middle of your painting board. Tape the paper in place on the top and bottom with 1-inch (2.5cm) Scotch Safe-Release Painters' Masking Tape, placing tape $^1/4$" (6mm) on the paper and $^3/4$" (19mm) on the board. Let the tape ends extend an inch or two (2.5cm to 5.1cm) beyond the paper. Rub out the bubbles.

Later, as you paint and have a lot of buckling, you may want to tape the other two ends of the paper, but leaving them open allows you to wipe up the excess water under the paper.

Making Transfer Paper

Transfer paper is used to reproduce the pattern onto your painting paper. You can buy transfer paper, or you may prefer making your own.

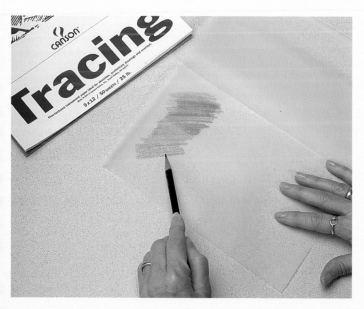

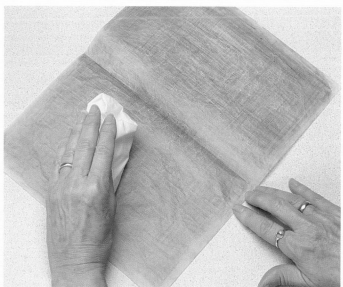

1 Fold a sheet of tracing paper in half and rub it with a soft lead pencil!. Half a sheet of paper is usually enough.

2 Wipe off the excess graphite with a tissue. Store your transfer paper folded. The unleaded half will provide a protective cover for the leaded half.

Transferring the Pattern

Transfer paper is just one means of transferring your pattern onto your painting paper. You can also use a light box or even a window. The fourth option is to sketch your design freehand rather than using a pattern.

1 Position the pattern on the watercolor paper and secure the top with tape. Do not tape to the paper, if possible, but to the board.

2 Place transfer paper under the pattern, darker side down. (You can test the correct side of the transfer paper on a corner of your painting paper.) Using the fine point of your stylus, trace the pattern lines with even pressure. Don't press too hard, or you will score the watercolor paper.

3 Check your tracing as you go to make sure the pattern lines aren't too dark.

TRANSFER PAPER

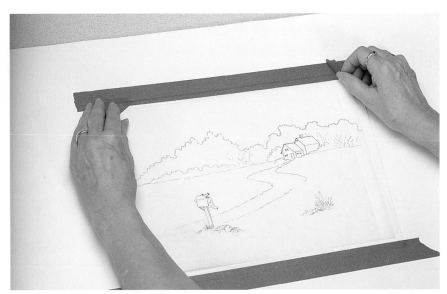

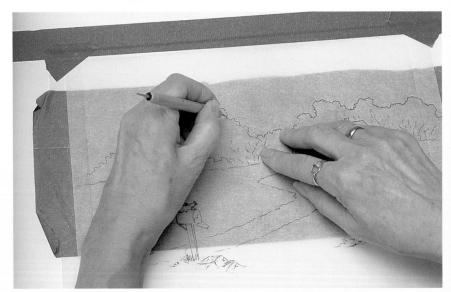

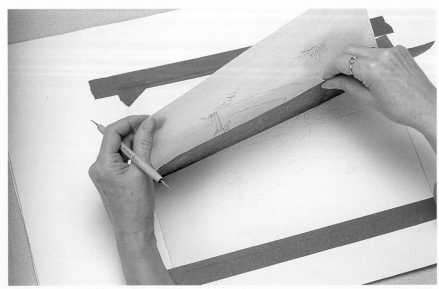

LIGHT BOX

1 Tape the pattern to the light box on all four corners.

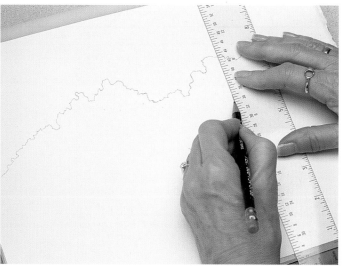

2 Position the watercolor paper on top of the pattern. Trace over the pattern with a sharp pencil, using a ruler for straight edges.

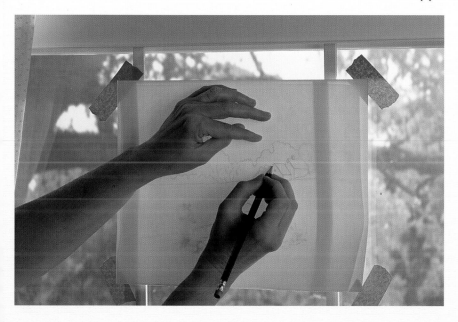

SUNNY WINDOW
A sunny window works on the same principle as a light box. Tape your design to the window and align your watercolor paper on top. Transfer using a sharp pencil.

SKETCHING
You can sketch your design directly on the paper, but if you erase for corrections, you must be careful that you don't scratch or damage the surface. This would create problems before you even started to paint.

To Stretch or Not To Stretch

You may have heard about stretching watercolor paper and wonder why this hasn't been mentioned. Stretching is usually done on light- to medium-weight papers that are larger than one-quarter of a sheet of mould-made paper (see page 13). The purpose of stretching is to keep the paper from buckling while you're working on it.

All but two projects in this book are done on 140-lb. (300gsm) paper (medium weight) in a size less than one-quarter of a sheet. The remaining two are done on 300-lb. (640gsm) paper (heavy weight). Buckling is minimal, so you'll only need to tape your paper to a flat surface.

If you ever need to stretch your paper, you must first soak it on both sides. This allows the paper to expand. Then fasten it to a board by either stapling, clamping or taping. As the paper dries, it shrinks, becoming taut and flat.

Setup

Left-handed painters put water, palette, brushes and so forth on the left. Right-handed painters put these materials on the right. The reason for having your supplies and water on the same side is so you are not mixing across your paper, where an accident is sure to happen.

A roll of toilet paper makes a good brush blotter. Paper towels may be used for blotting brushes or for wiping up excess water.

You'll need two containers of water—one for diluting and mixing paint as well as for rinsing brushes, the other for wetting the paper with clean water. Placing a brush over the clean water container will help you remember which one it is.

WATERCOLOR
Techniques

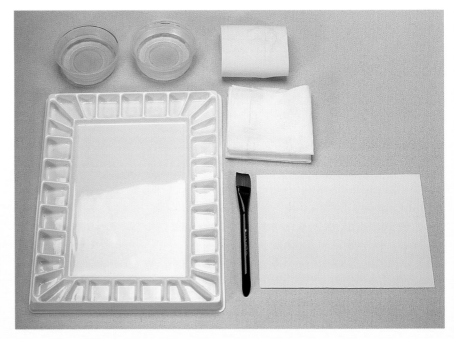

Left-handed setup

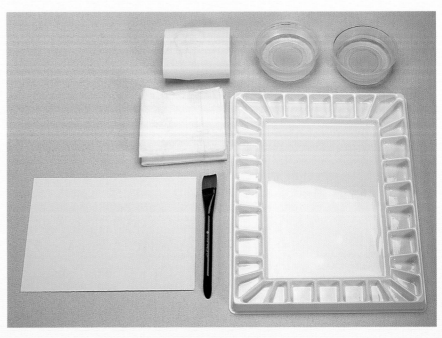

Right-handed setup

Graduated Washes

A graduated wash is a painting technique in which the color gradually fades from a deeper to a lighter value. This can be done wet-on-wet (wet brush on wet paper) or wet-on-dry (wet brush on dry paper). Following are practice exercises for each technique.

The **wet-on-wet** graduated wash is commonly used for putting in skies. Wet paper helps the painter create a soft effect going from dark to light while allowing time to wipe out clouds or add soft images at the horizon. It gives the beginner a longer working time and results in a pleasing look.

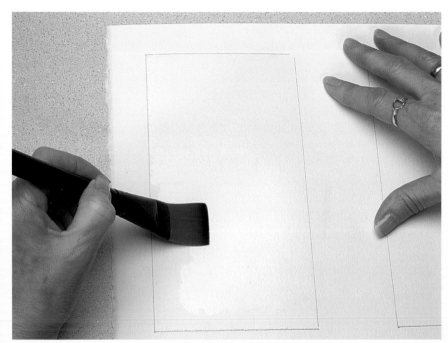

1 Wet down your paper with a 1-inch (25mm) flat brush.

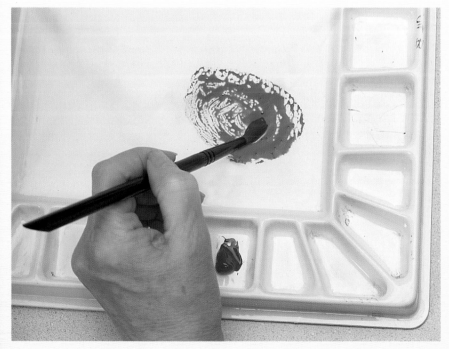

2 Dampen a no. 8 round brush and loosen up a puddle of paint on your palette. To do this, I use my brush like a scoop, adding water until the paint is the consistency of cream. Mix at least a 2-inch (5.1cm) diameter puddle. NEVER swish your brush into the water until the desired consistency has been reached. To do so would release all the pigment into the water instead of onto your palette.

Graduated Washes, continued

3 Your paper has probably started to dry while mixing the paint, so re-wet the paper with your flat brush. Let the paper absorb the water until it has a nice even sheen. Hold the paper at eye level to look for dry spots.

 Now you're ready to paint.

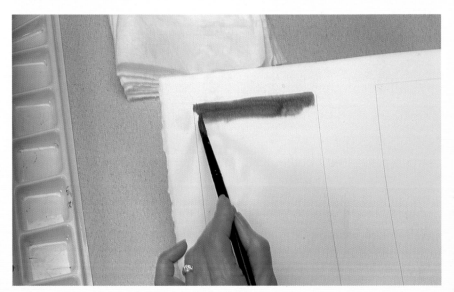

4 Elevate the top of your paper so the color can flow down. I place the roll of masking tape under the top of my painting board to prop it up.

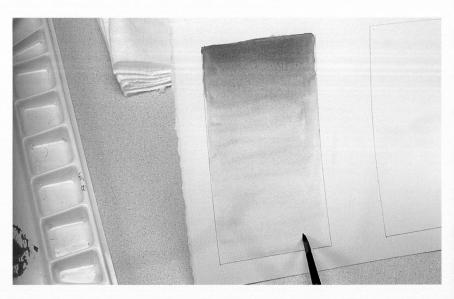

5 The first areas you paint will be darker, gradually fading as you continue to work the color.

 If you need to add more color, do so at the top and continue to work down.

The **wet-on-dry** graduated wash can be used to paint a sky, but a beginner may have a more difficult time getting good results than with a wet-on-wet wash. I use the wet-on-dry technique to shade objects, the darkest area being a shadow, which softens out to the light part of the paper. Here's how it works.

Do not wet the paper. Make sure you have plenty of fluid paint in a no. 8 round brush. Spend time working the paint into the bristles. Elevate the top of your dry watercolor paper. Paint a stripe of wet color. Rinse your brush and continue to pull the color from where you left off, making successive overlapping strokes with clean water to move the color down.

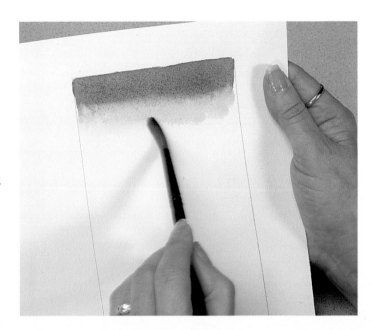

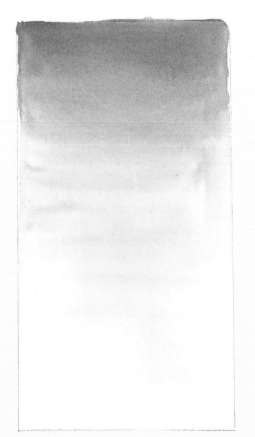

WET-ON-WET
GRADUATED WASH

WET-ON-DRY
GRADUATED WASH

Drybrushing

Drybrushing is used to apply texture to an area. You might use it on such things as fence posts, tree trunks, old buildings or rocks.

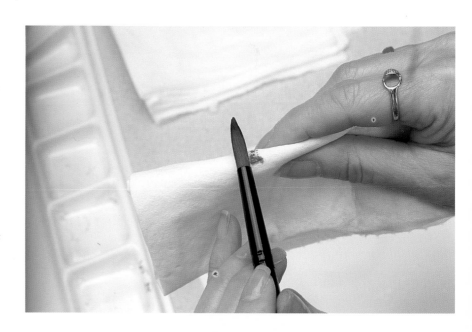

1 Load a no. 8 round brush with slightly dry paint. If you feel too much moisture is in the brush, remove excess water by placing a paper towel where the ferrule (the metal part of the brush) meets the bristles.

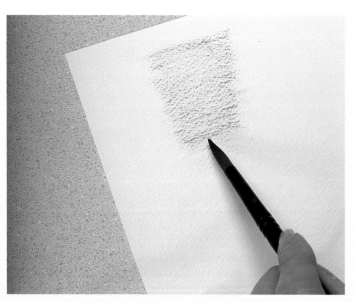

2 Hold the no. 8 round brush parallel to the surface. Using the side of the brush rather than the tip, drag it across the paper. The paint will adhere to the raised bumps in the paper, showing the texture.

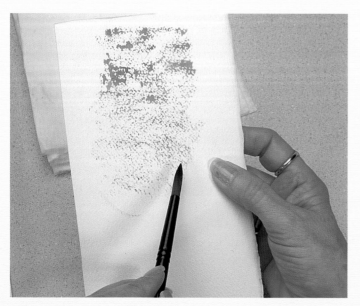

3 Here you see that the brush had a bit too much water and is blotching at the top. As the excess water leaves the brush, the dry-brush effect takes on the more desired even appearance.

Flat Wash

The flat wash is used for filling in an area with even color. It could be used on such things as a house, roof or flower petal.

Fully load your brush with paint. On dry paper, pull a puddle of color along with your brush to fill in the desired space with an even coat.

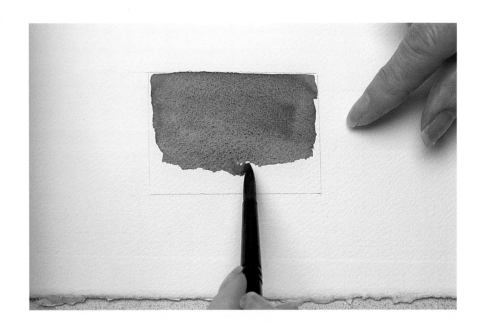

Glazing

Glazing is applying a thin coat of paint over a dry area, generally one that has already been painted.

COBALT BLUE COBALT BLUE GLAZED NEW GAMBOGE
 WITH NEW GAMBOGE

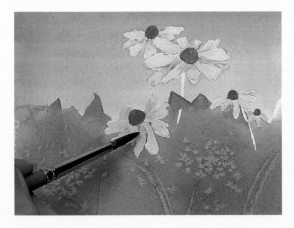

Glazing can unify and intensify, making an area dominant, as with the yellow and orange applied over the basecoat of these black-eyed Susan petals. (See "Black-eyed Susans," page 78, step 7.)

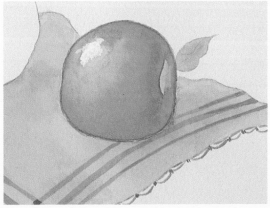

The progressive color values on this apple are created by applying several layers of glazing, each covering a bit less of the apple than the one before. (See "Apples on Tea Cloth," page 104, step 5.)

In this chapter I introduce you to the special effects used in this book, but the sky's the limit. Special effects are an opportunity to try anything your mind can conjure up.

For example, once while painting the siding of an old shed, I experimented with a comb that was missing a few teeth. As I ran the comb vertically down the wet paper, the color settled perfectly into the grooves, creating the desired effect. I imagine someone else had tried this before, but to me it was a new technique.

If you've done other crafts, I'm sure some of your supplies will make wonderful special effects. Someone who sews might mottle a background with lace. A scrapbook enthusiast might enhance a painting with a rubber stamp. Let your imagination go!

CHAPTER 4

SPECIAL
WATERCOLOR *Effects*

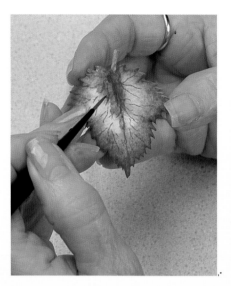
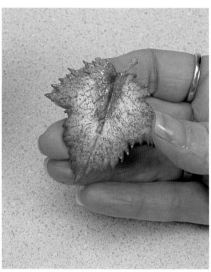

Glitter Paint

Tiny bits of metal in otherwise clear binder create a sparkle over already applied color. Note the difference between the leaf without glitter paint in the upper left photo and the leaf with glitter paint on the upper right.

For the project, see pages 34–41.

Iridescent Medium

For a more shimmery effect, use an iridescent medium. Here I'm brushing the medium directly on the painting, but you can also mix the medium in your watercolors.

For the full project, see pages 82–91.

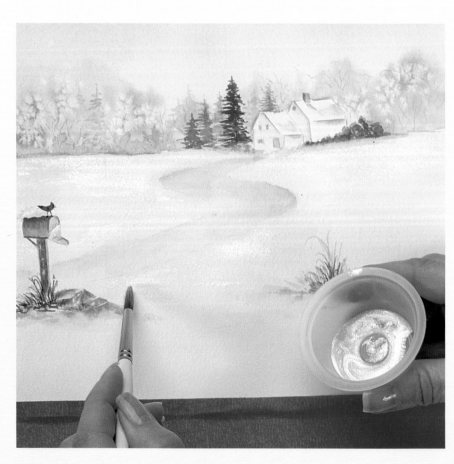

Toothbrush

A toothbrush can create different speckling effects, depending on the amount of water in the brush or on your paper. Test your speckles on a separate sheet of paper before you apply them to your project. There's no right or wrong look, so just go for the effect that pleases you.

First mix a puddle of paint to a medium value. Saturate the bristles of the toothbrush and then run either your finger or a palette knife down the bristles, directing the brush in the direction you want your paint to spatter. If your speckles appear too dark, quickly press straight down with a clean paper towel to soften.

This speckling was done on the memory album cover. For the full project, see pages 56-65.

This small speckling on the black-eyed Susans project was created with a relatively dry brush and paper.

For the full project, see pages 74-81.

Wetter paper produces the larger speckling you see on this poinsettia gift bag.

For the full project, see pages 42-55.

Salt

The texture created with sprinkled salt can be used in many different situations. In the winter scene project, it appears as snow on tree branches. In the black-eyed Susan project, it gives the effect of Queen Anne's lace.

First apply color using either a wet-on-wet or wet-on-dry technique. The more intense the color, the more noticeable the salt effect. Sprinkle the salt while the paint is still wet, but not puddled. The salt will absorb the water around it and leave light spaces. Do not dry the area with a hair dryer or brush the salt off too soon, or you'll run the risk of streaking the watercolor.

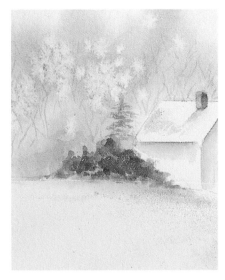

Snow Effect
(For the full project, see pages 82-91.)

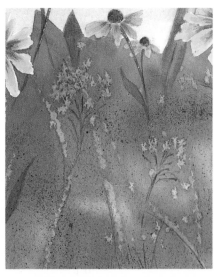

Queen Anne's Lace Effect
(For the full project, see pages 74-81.)

Three Kinds of Salt

You can use table, kosher or rock salt. The bigger the salt crystals, the bigger the areas that are absorbed. Notice that the texture becomes more dense as the salt gets larger.

TABLE SALT KOSHER SALT ROCK SALT

Sponge

Different kinds of sponges can be used to get different textures. A natural sea sponge was used to form the foliage in the fall scene below. A synthetic sponge, such as you might keep at your kitchen sink, would make a different impression. Experiment!

First dampen the sponge in a small amount of water. Then wring it out, making sure there's no excess moisture. Dab the sponge into your paint and then onto your paper. Use a light touch until you see how much paint will be deposited. Then, using different amounts of pressure, form your trees.

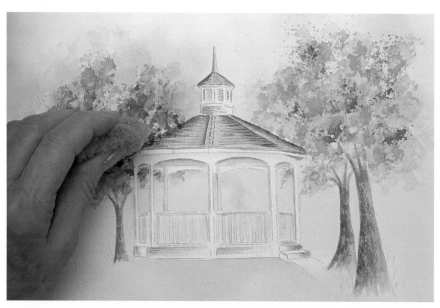

The foliage on these trees was formed by dabbing on successive colors with a sea sponge. Here you see the last color being applied to the left tree. The right trees give you a better view of the multiplicity of colors.

For the full project, see pages 92-99.

Tape

Tape is used to mask an area from paint. When ripped, it can cover the irregular foliage of trees. Cut with a knife, it can form straight edges around windows. Below, its creates a lattice.

There are many kinds of tape, such as painters', masking and packing. They all can be used, although one tape may work better than another on a certain type of paper. For example, packing tape works better than masking tape on a rough-surfaced paper because it conforms better to its contours.

No matter which tape you use, you should practice with it. Make sure it's pressed down, allowing no seepage, and that it will come off without ripping the surface of the paper. If necessary, you can ease the removal of tape by heating it gently with a hair dryer.

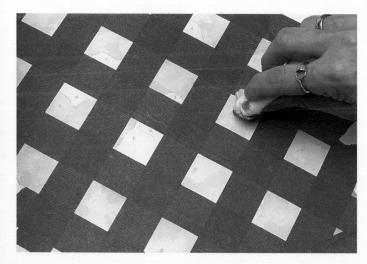

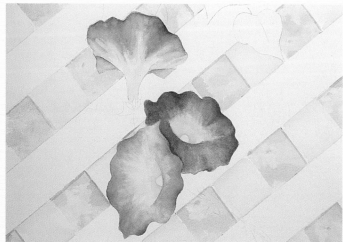

1 Scotch Safe-Release Painters' Masking Tape (the blue strips in this photo) allows me to dab paint quickly into the exposed squares.

2 Remove the tape, add a bit of shading, and you have a trellis for these morning glories.

For the full project, see pages 66-73.

Doily

Doilies of all sizes and types can be used as stencils. Round or square, they all add an interesting effect to the paper. Even lace can be used for forming a different pattern.

I always like to practice this technique before I apply it to my project to make sure the paint is just the right consistency and will not bleed under the doily.

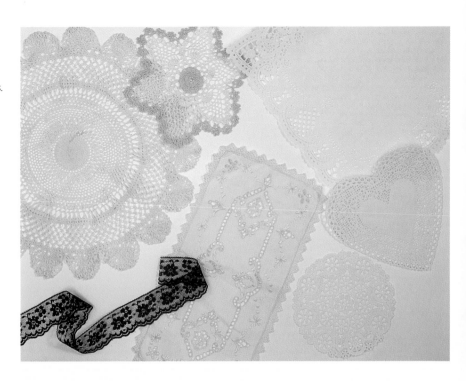

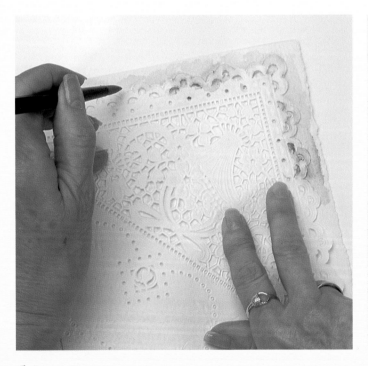

1 Hold the doily steady on the paper and apply the paint with a brush or a sponge, whichever works better for you. If you reuse the doily, either let it dry first or turn it to a fresh, dry area.

2 Here you see the finished effect of the doily pattern (as well as some toothbrush speckling) on the memory album cover. For the full project, see pages 56-65.

Masking Fluid

Masking is used to preserve the white of the paper as you paint over it. To successfully mask out an area, use a synthetic no. 2 or no. 4 round with a good point. A badly formed brush will bring aggravation and disappointment. Dampen the brush and work soap into the bristles, forming a nice point. The soap stays in the bristles while applying the mask.

Follow the manufacturer's directions as to whether your masking fluid should be shaken or stirred. Apply the masking fluid as carefully as if you were painting. Then clean your brush immediately (in a separate tub of water or under the faucet) and let it dry naturally. If you set aside your painting for several months, you may find the mask difficult to remove. But under normal circumstances, it comes off easily with a rubber cement eraser.

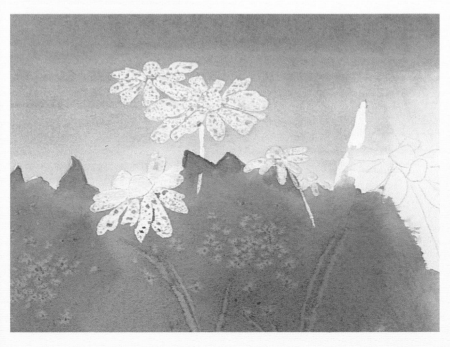

1 Here you see me carefully applying masking fluid to black-eyed Susan flower heads.

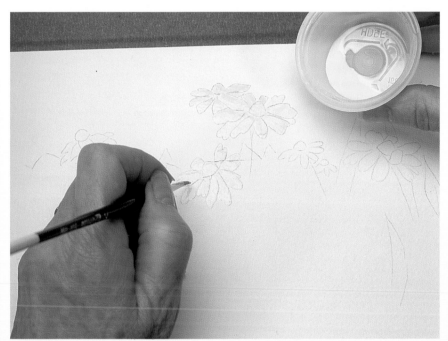

2 The blue sky and green grass were applied right over the masked areas. Notice how the paint beads on top of the mask.

For the full project, see pages 74-81.

Cotton Swab

I use cotton swabs as miniature paintbrushes to soften an area with too much paint, to stop the flow
of unwanted color or to create a highlight. Their uses are limitless—keep them handy.

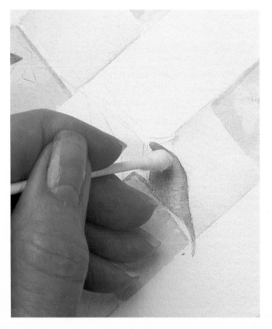

1 (*left*) Here I'm creating a high-
light on a morning glory bud.

2 (*right*) Adding shading around
the highlight makes it stand out.
For the full project, see pages 66-73.

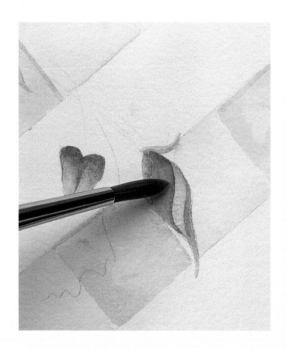

Beveled-handle Brush

A beveled-handle brush is a helpful tool used in pushing paint to remove color from an area. The stronger
the pigment, the easier it is to see the strokes created by the handle. The moisture in the paper has to be
just right for this effect to be successful. If the paper is too wet, the color runs back into the grooves; if too
dry, nothing happens.

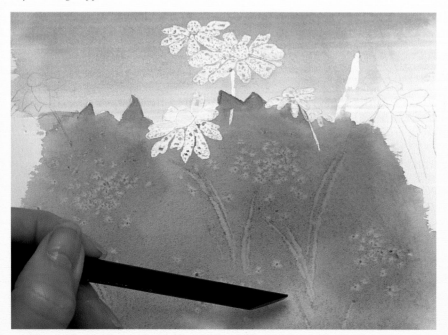

A beveled-handle brush is perfect for scraping stems
and leaves on these black-eyed Susans and Queen
Anne's lace. For the full project, see pages 74-81.

Craft Knife

With a craft knife you can scrape a small amount of paint off the paper. This is useful for highlighting or for correcting little painting errors.

Using the tip of the knife, gently remove the top layers of paper. This technique damages the paper, so it's used mainly when you don't plan to apply more paint.

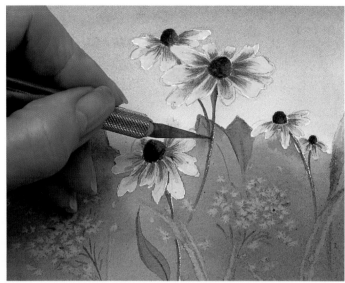

I used a craft knife to scrape a highlight on this flower stem. For the full project, see pages, 74-81.

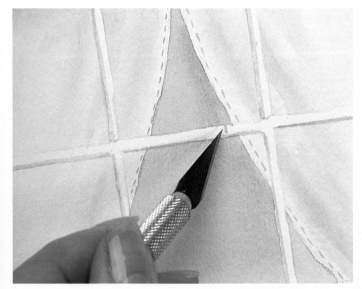

The fleck of stray paint on this window mullion can easily be scraped off. For the full project, see pages 116-125.

Sand Paper

The sandpaper technique is done in much the same way as the craft knife, but a broader area of the paper is removed.

Using the sandpaper, you remove color from the top bumps of the paper. This works best on cold-pressed or rough paper.

The sandpaper technique is not used in this book, but you can see from this photo how it could add a nice sparkle to a lake.

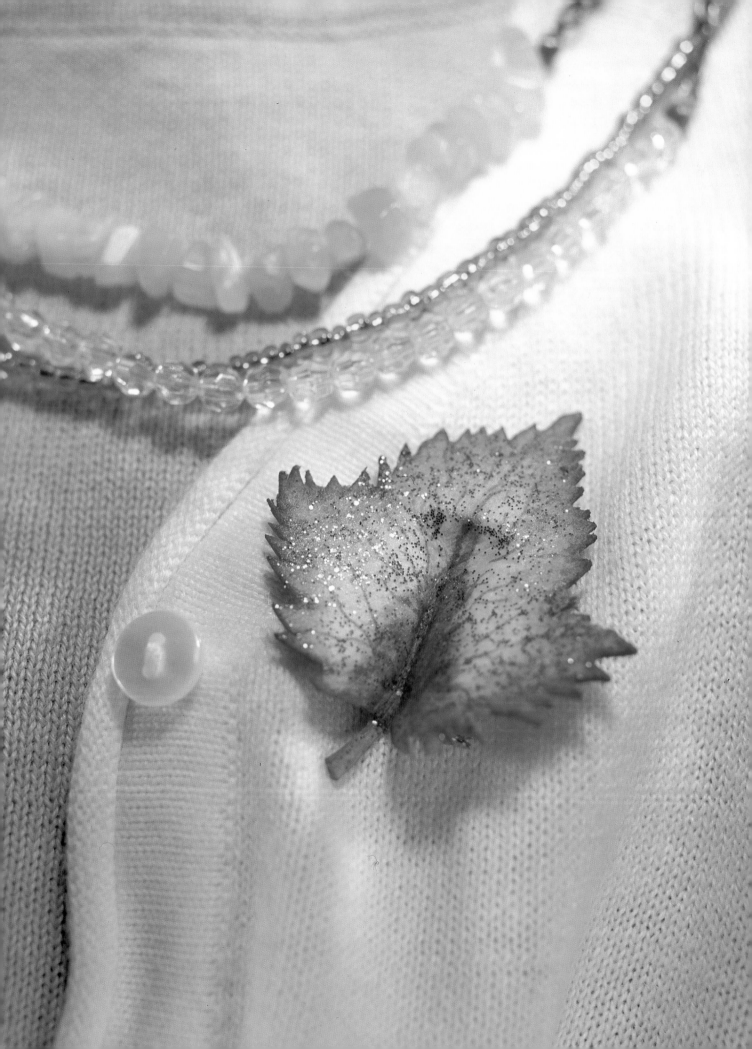

Autumn Leaf Pin

Paint: WINSOR & NEWTON ARTISTS' WATER COLOURS

NEW GAMBOGE

BRIGHT RED

BURNT SIENNA

BURNT UMBER

DecoArt Craft Twinkles

ORANGE

As I walk in the fall, I always love seeing all the wonderful colors. This unique leaf pin was made from a maple leaf I picked up in my backyard.

I realized that this project would be just perfect to inspire my students, allowing them to experiment with colors and glitter. Each student's pin turned out different. Many even decided to try other leaves, such as oak or holly, to use as gifts. They took their found leaves, traced them and either enlarged or reduced them to fit their needs.

For this project I used the maple leaf pattern on page 36, but you can apply the same instructions using any of the patterns on the same page. Or, like my students, you can create your own pattern.

M A T E R I A L S

Surface
Arches 300-lb. (640gsm) watercolor paper:
 cold-pressed
 3" x 3" (7.6cm x 7.6cm)

Royal Majestic Brushes
• no. 1 liner
• no. 8 round

Additional Supplies
• extra tub of water (to soak paper)
• small sharp scissors
• spring clothespin
• hair dryer (optional)
• craft brush (to apply DecoArt Craft Twinkles)
• ³/4-inch (1.9cm) jewelry pin
• craft glue or glue gun

Patterns

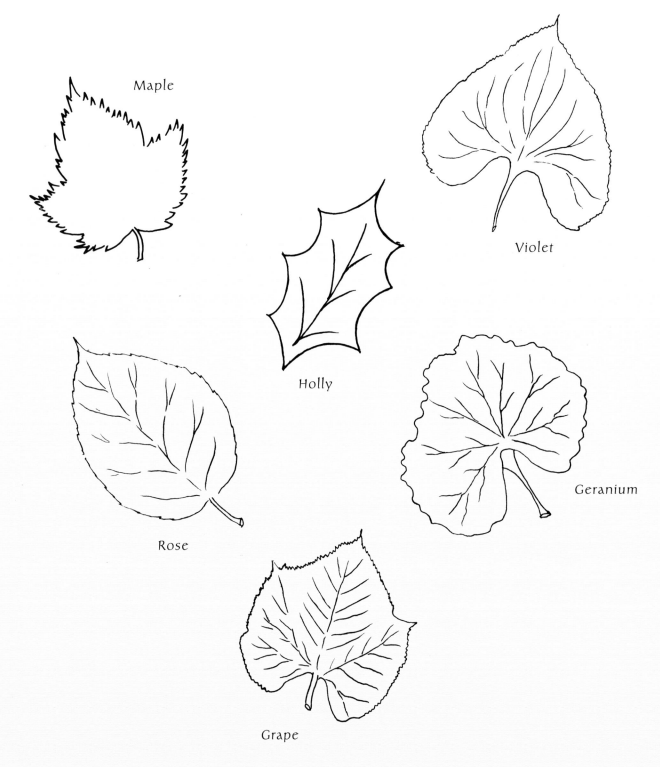

Maple

Violet

Holly

Rose

Geranium

Grape

These patterns may be hand-traced or photocopied for personal use only. Patterns are full size.

Preparation

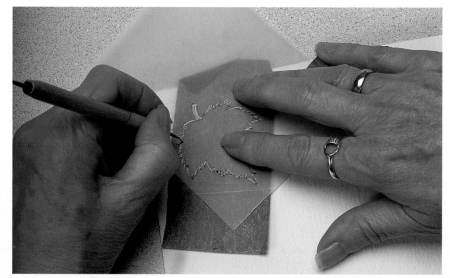

1 Transfer the pattern onto the watercolor paper as described on pages 18-19. Make the pattern lines extra dark.

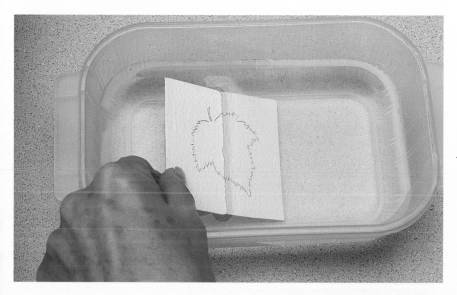

2 Place the watercolor paper in water.

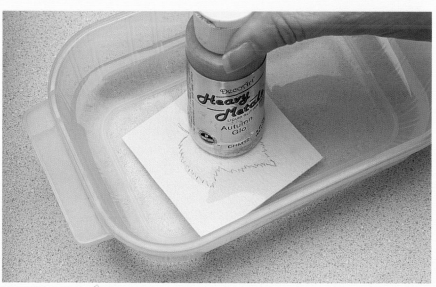

3 Weigh the paper down so it stays submerged. Let the water soak in until the paper is soft, pliable and easy to cut (about 5 to 10 minutes).

While the paper is soaking, prepare your colors by adding water to create the consistency of cream. This demonstration uses New Gamboge, Bright Red, Burnt Sienna and Burnt Umber, but you can use any colors you like.

Preparation, continued

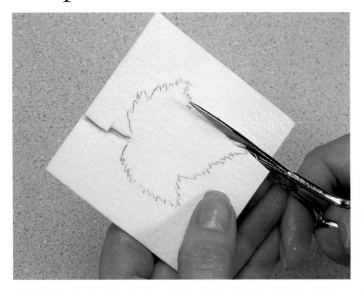

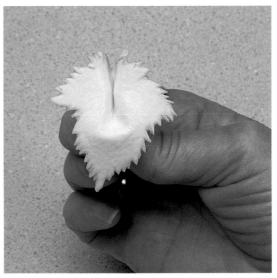

4 Use small, sharp scissors to cut out the pattern. As you work, if the paper becomes too dry for easy cutting or shaping or painting, place the leaf back in the water.

5 When the cut leaf is saturated with water and pliable, pinch it to form a depression where the center vein would be.

Color and Shape

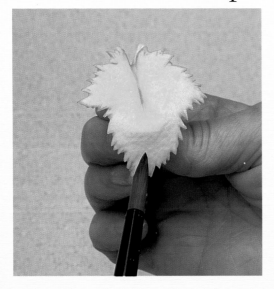

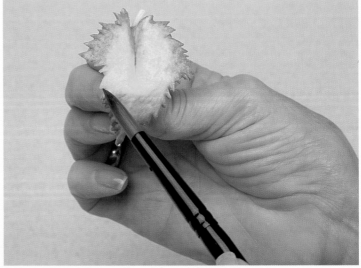

6 Using a no. 8 round, paint the whole leaf front, wet-on-wet, with New Gamboge. Remember that watercolors dry lighter.

7 With the same brush, apply darker values on the outside edges, holding the leaf so the colors will flow toward the center vein. Here I've randomly applied Bright Red and Burnt Sienna.

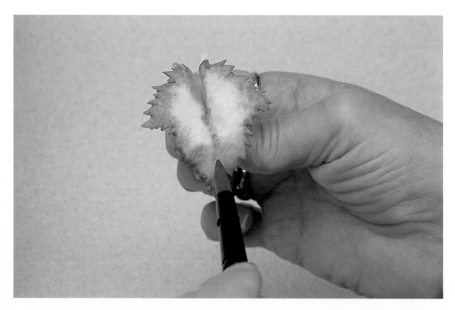

8 Now put some color down the center vein. I've used Burnt Sienna. The paper still needs to be damp at this point.

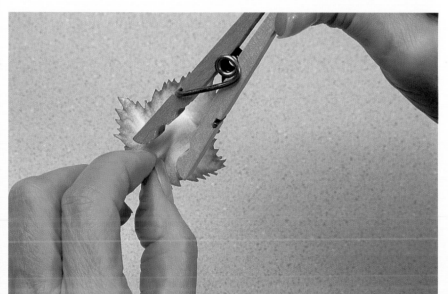

9 Pinch the underside of the leaf with a spring clothespin and let dry. You can use a hair dryer to speed the drying.

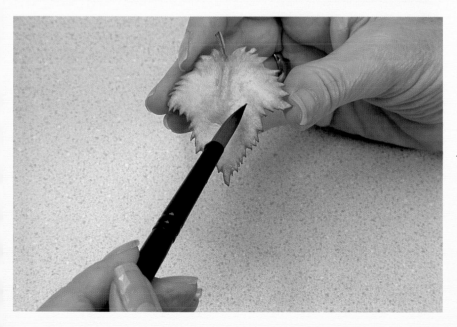

10 Remove the clothespin and paint the back in Burnt Sienna, striving for even color.

Veins, Glitter and Finishing

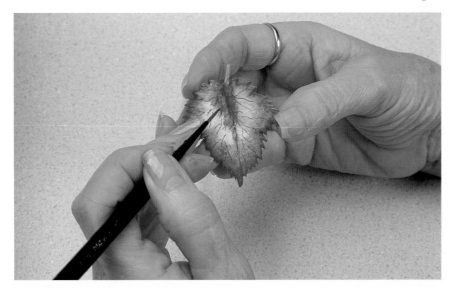

11 Using the no. 1 liner, thin Burnt Umber to an ink-like consistency and paint a center vein plus some veins coming off the center. Let dry.

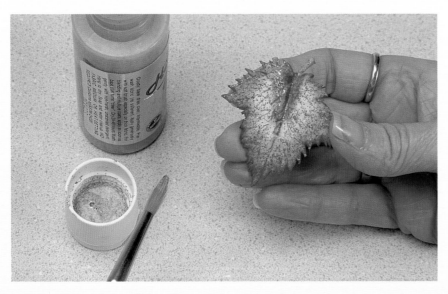

12 Using a craft brush, apply the glitter paint. DecoArt Craft Twinkles (Orange) is used here. This goes on milky but dries clear.

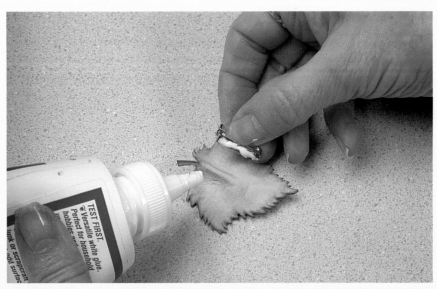

13 Attach a ³/4-inch (1.9cm) jewelry pin to the back of the leaf with craft glue or a glue gun.

COMPLETED AUTUMN PIN

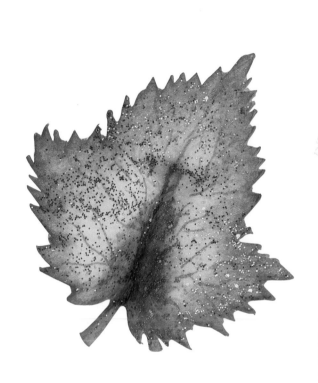

With a little ingenuity, you'll find many ways to use these leaves besides as pins. Here are a few ideas to get you started:

• Create hair decorations. Glue two or three leaves to a plain barrette. Or glue on the pin and then attach the leaf to an elastic hair band.

• Make earrings. Reduce the pattern size if you want them a bit smaller.

• Decorate place cards for a special dinner.

• Glue a leaf or two to napkin rings.

• Cut out a cardboard picture frame and cover it with leaves for an interesting 3-D look. Or glue a few leaves to a ready-made frame.

• Attach one as part of the design of a homemade greeting card.

• Use them as wrapping decorations on small gifts.

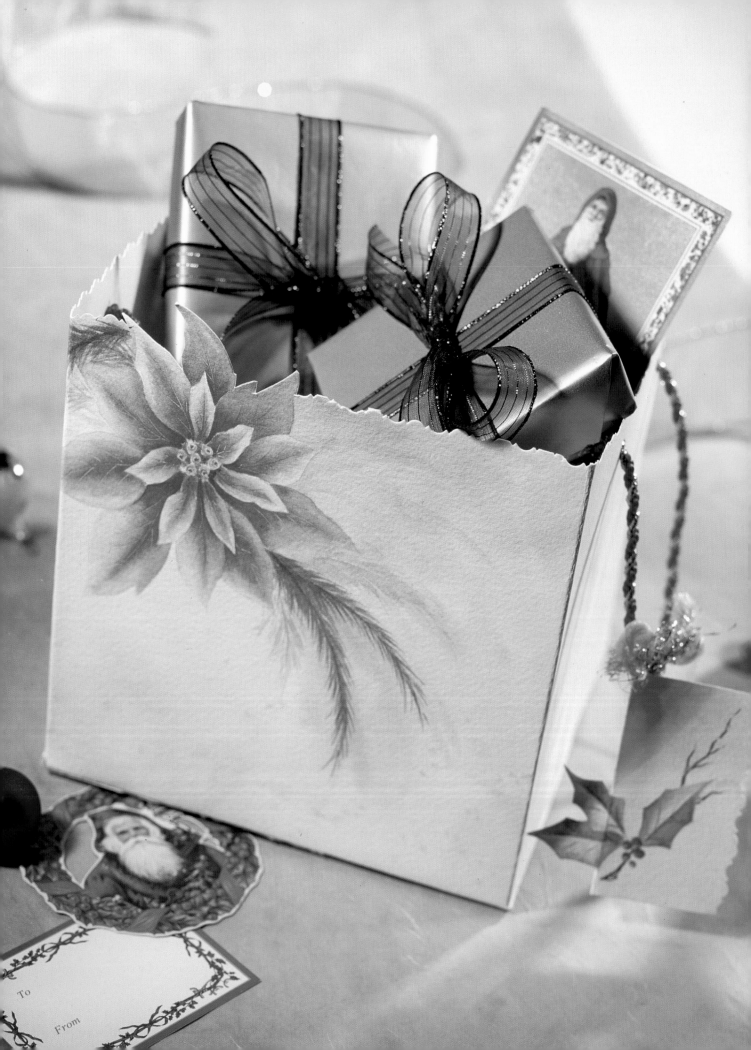

Poinsettia Gift Bag and Tag

Paint: WINSOR & NEWTON ARTISTS' WATER COLOURS

AUREOLIN

ROSE MADDER GENUINE

ALIZARIN CRIMSON

COBALT BLUE

Mixes

LIGHT YELLOW GREEN:
AUREOLIN +
COBALT BLUE

GREEN:
COBALT BLUE +
AUREOLIN

DV. BROWN:
ALIZARIN CRIMSON +
A DARK VALUE
OF GREEN

It's nice to be able to use your watercolor painting to create functional items instead of only decorative ones. This gift bag is perfect for delivering a plant, or you could use it for a dried flower arrangement. Made in a smaller size, it could hold potpourri for the holidays. A set of gift tags could be used as place cards for your holiday table.

The surface of the not-yet-folded bag allows you to loosen up and do a wash on a large area. Combined with the toothbrush speckling technique, you can't go wrong.

This project also lets you choose between a soft or defined look for the poinsettias. On the opposite page and on page 55 you see the defined look. On page 54 you see the soft look.

M A T E R I A L S

Surface

Arches 140-lb. (300gsm) watercolor paper:
 cold-pressed
 12" x 29" (30.5cm x 73.7cm) for bag
 4" x 3" (10.2cm x 7.6cm) for tag

Royal Majestic Brushes

- no. 1 liner
- no. 6 round
- no. 8 round
- 1-inch (25mm) flat wash

Additional Supplies

- ruler and soft lead pencil
- toothbrush
- hair dryer (optional)
- masking supplies: Winsor & Newton Art Masking Fluid, no. 2 round, soap, extra tub of water, rubber cement eraser
- stylus
- decorative-edged scissors
- straight-edged paper-cutting scissors (both regular and small sizes are recommended)
- craft glue or glue gun
- paper punch
- 50" (127.0cm) decorative cord, cut in half (for bag handles)
- 9" (22.9cm) thin decorative cord (for optional method of attaching tag)

Patterns

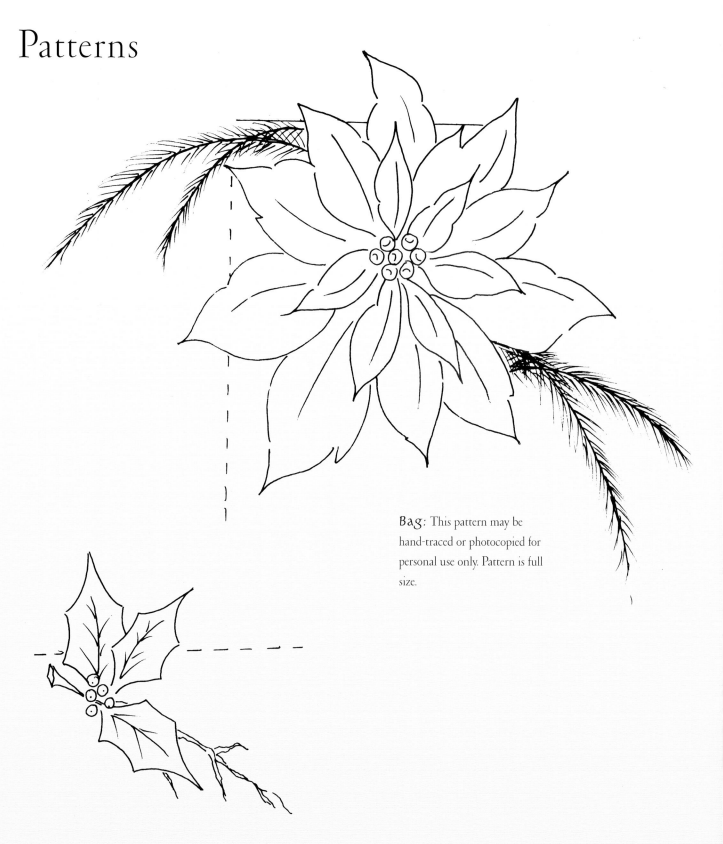

Bag: This pattern may be hand-traced or photocopied for personal use only. Pattern is full size.

Tag: This pattern may be hand-traced or photocopied for personal use only. Pattern is full size.

Preparation

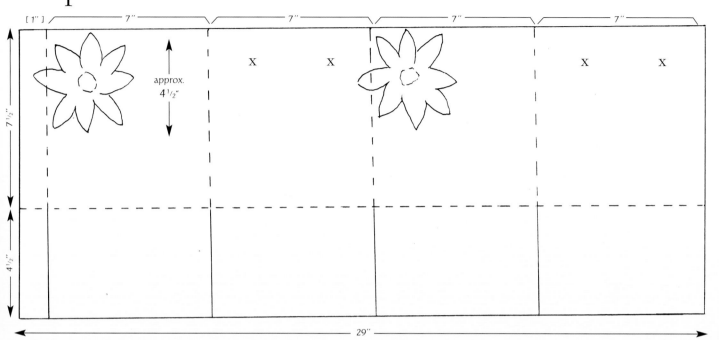

Key

————————	CUT LINE
- - - - - - - - - -	FOLD LINE
X	HOLE PUNCH

1 With a soft lead pencil, lightly mark the bag cutting and folding lines and the hole-punch Xs on your bag paper, using this schematic diagram as your guide.

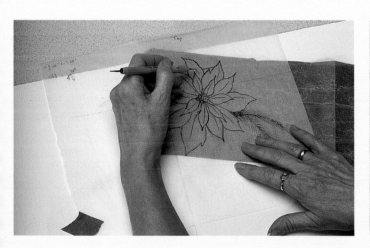

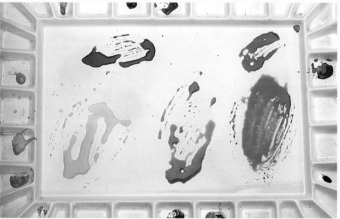

2 Transfer the poinsettia pattern onto the paper as explained on pages 18-19. (Notice that the bag has two poinsettias.) Use the above diagram for placement.

3 Mix your paints with water to a consistency between cream and ink. Start with a palette of Aureolin, Rose Madder Genuine, Alizarin Crimson, Cobalt Blue and Green. To check your colors, take the rich color on the palette and use your brush to thin it with water. Absorb extra moisture on the brush with a paper towel at the ferrule (metal part), and paint a color swatch on a scrap of watercolor paper.

Bag Background

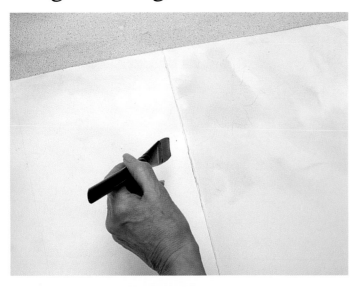

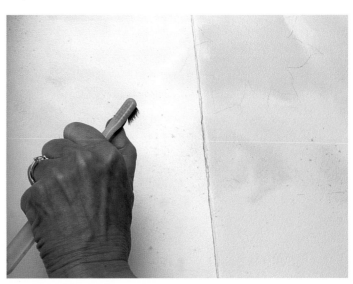

4 Wet your paper with a 1-inch (25mm) flat brush. Apply as many coats of water as necessary to create a nice even sheen. With the same brush, randomly slip-slap on patches of Aureolin, Rose Madder Genuine, Alizarin Crimson and a bit of Cobalt Blue. Place yellow under the flower area.

5 With a toothbrush, spatter Cobalt Blue randomly. See page 27 for instructions on using this technique.

Hint

As your toothbrush spatters absorb into the paper, the speckles they create will tend to get larger, especially if your toothbrush or paper is very wet.

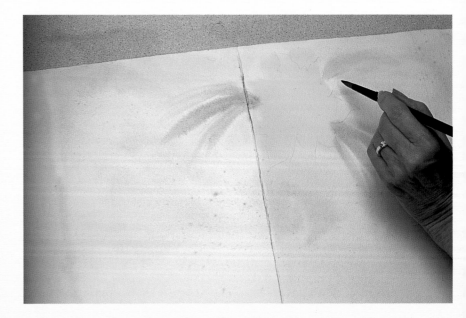

6 With a no. 8 round, pull out a Green base for the pine branches. Let dry till the paper no longer feels cool. If using a hair dryer, keep the dryer in motion so it doesn't stay too long in one spot.

Poinsettias

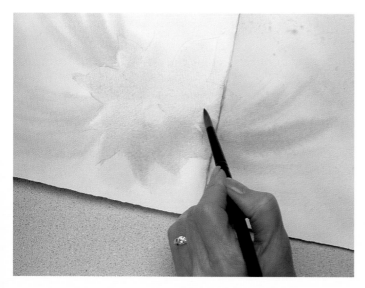

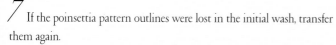

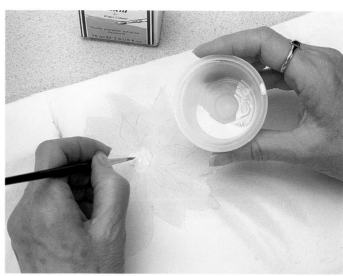

7 If the poinsettia pattern outlines were lost in the initial wash, transfer them again.

Because there are two poinsettias on this bag, you can experiment with two different looks—soft and defined. I used one of each, which you can see in the two completed bag views on pages 54-55. You may prefer to make both soft or both defined. Both looks start with this step.

Dampen the petals of the poinsettia with a no. 8 round. Add water to Rose Madder Genuine to create a soft pink, and apply it to the poinsettia petals, turning the paper so you are always stroking away from the center.

8 If you want to keep this soft-petal look, skip to step 14. Otherwise, retransfer the complete poinsettia design, if needed.

Dampen a no. 2 round brush and work it into a piece of mild soap until the brush is very soapy. This will protect the bristles from the masking fluid. Be sure the fluid is well mixed, following the manufacturer's instructions as to whether you should shake or stir it.

Mask the poinsettia center. When finished, rinse your brush in your extra tub of water and then discard the water. Never paint with water that you have used to rinse your masking brush.

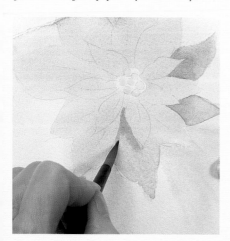

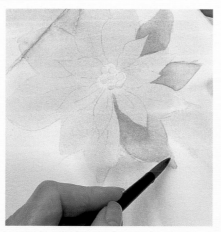

9 As you continue, avoid painting two adjoining petals in a row. Instead, skip around the flower so the colors won't run into each other. Notice that besides alternating petals, I also paint the undermost ones first.

Using the no. 8 round, shade the poinsettia with Rose Madder Genuine, using the wet-on-wet method.

10 Then apply clean water to the brush and extend the shading to soften the edges.

Hint

IMPORTANT: Don't use your best brush when masking. If you forget to rinse, you'll ruin it. On the other hand, the brush you use needs to have a decent point, or it will be too hard to control.

Poinsettias, continued

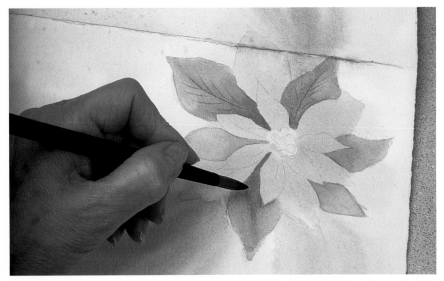

11 One at a time, rewet the petals and apply a dark value of Alizarin Crimson down the center vein area. You can go back and add Alizarin Crimson as many times as you please to create the desired intensity, as long as the paper remains damp.

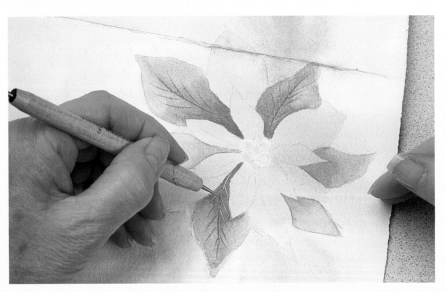

12 While the petal is still damp, use a stylus to score the paper and create veins. The stylus will actually put an impression in the paper into which the paint can flow.

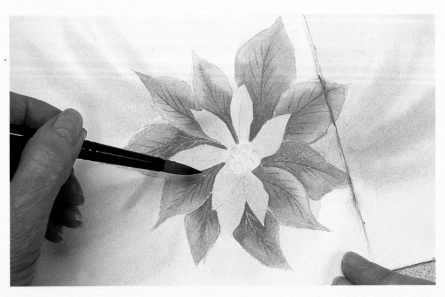

13 In the previous photo, you can see that I've nearly completed the first set of alternate petals. Once those were done, I started on the second set of alternate petals. Here you can see I've completed the lower petals. Continue painting the petals in this manner, following steps 9 through 12 and never painting on an adjoining damp area.

Pine Branches

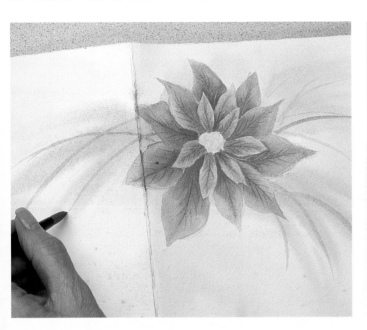

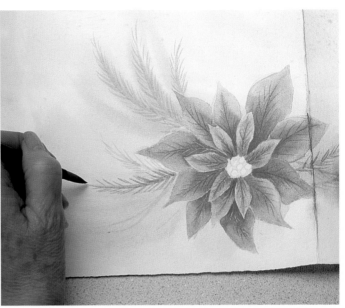

14 With Green on the tip of a no. 6 round, stroke in the pine branches, pulling from the flower out.

15 Form a lighter value of the same color by adding water, and stroke in light pine needles with the brush tip. Always pull the stroke from the main branch out, painting in the direction the needles grow.

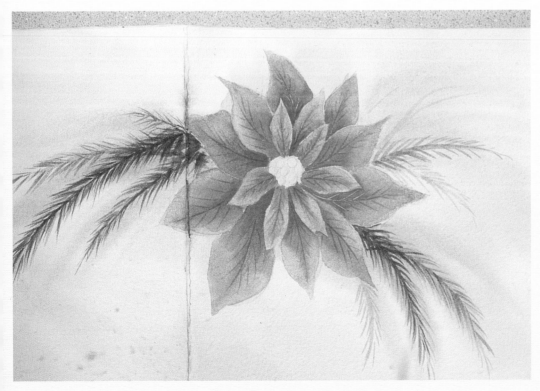

16 Paint with less water will create medium- and dark-value pine needles. As you continue to paint needles, the water will evaporate, which will darken the color value.

Flower Heads and Bag Edge

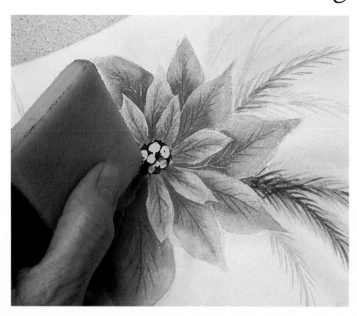

17 Dab a dark value of Green around the flower heads and let dry. Remove the mask from the flower heads with a rubber cement eraser.

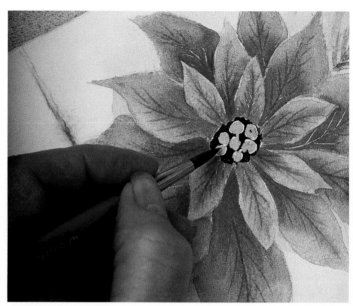

18 Load a no. 6 round with Light Yellow Green and paint each flower head.

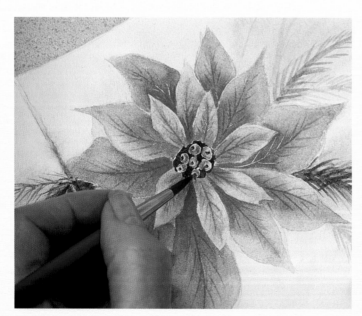

19 Returning to Green, add a U-stroke to each flower head. Pull the strokes in different directions to show different positions of the heads. Add a dot of Alizarin Crimson to each head on the remaining Light Yellow Green area.

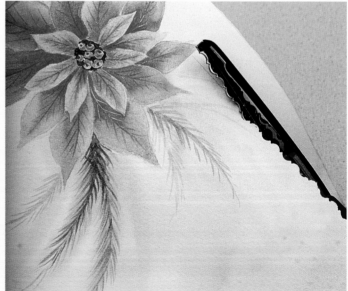

20 Cut the upper edge of the bag with decorative-edged scissors of your choice. The decorative edge you see here is called Victorian. Stop when you get to a poinsettia and switch to regular scissors. Then cut on the poinsettia outline above the decorative edge. This portion of the poinsettia will extend above the bag edge.

Holly Leaf Gift Tag

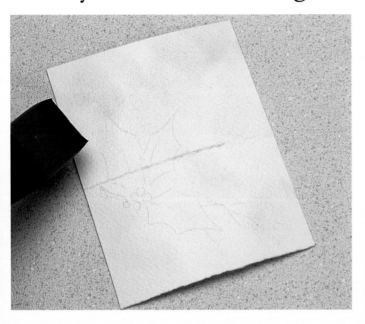

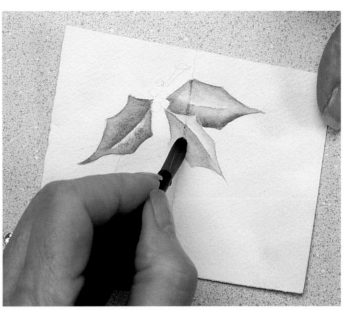

21 Fold your tag watercolor paper in half. Unfold the paper and transfer the pattern as explained on pages 18-19. Notice that the top two leaves cross over the fold.

Wet the paper with a 1-inch (25mm) flat brush. Then dab at random a light value of Rose Madder Genuine and Green.

22 Working one leaf at a time, use a no. 8 round to wet the two halves with a light value of Green. IMPORTANT: leave a dry center vein so the shading color won't run. Then with a darker value of the Green, add shading.

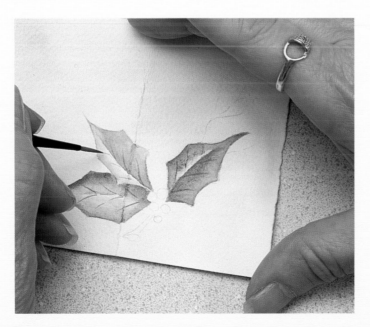

23 Allow the leaf to dry. Using a dark value of Green, pull in the veins with a no. 1 liner.

Holly Leaf Gift Tag, continued

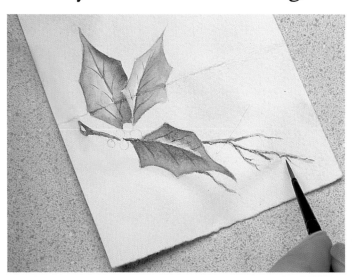

24 Create a dark- and a light-value Brown. The light value is created by adding water to dv. Brown. Paint the branch with the lighter value on a no. 1 liner. Let dry. Add shading with the darker value.

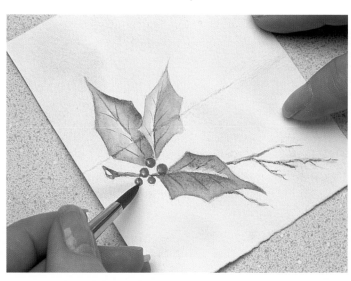

25 Use a no. 6 round to dampen the berries with water, leaving a dry highlight area. Then paint them with Alizarin Crimson, leaving the dry highlight area white.

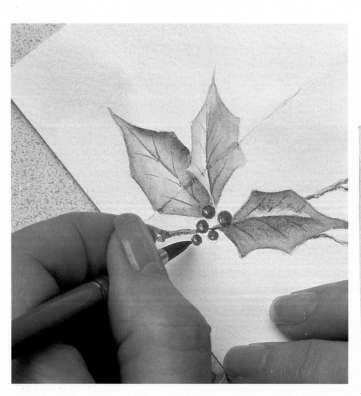

26 Add shading on the right with a darker (drier) value of Alizarin Crimson. Use dv. Brown to add a seed dot to each berry.

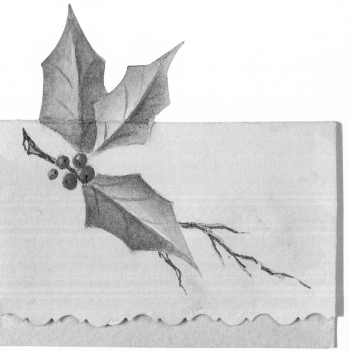

27 Cut the lower front edge of the tag with your decorative-edged scissors.

Insert the point of small straight-edged scissors right where the gift tag fold meets a holly leaf edge. Cut along the leaf, above the fold only.

For an added touch, you can paint a light-value stripe of Alizarin Crimson along the tag's inner bottom edge.

Here you see the completed tag.

Assembly

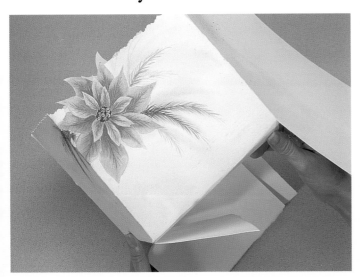

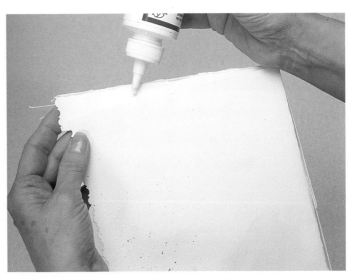

28 To assemble the bag, cut slits on the four cut lines beneath the painting up to the dashed fold line. Fold the sides of the bag inward, making a good crease. Be sure the extra 1-inch (2.5cm) strip is on the inside of the bag. Fold up the bottom flaps on the dash lines.

29 Glue the bag bottom in place. Then glue the extra 1-inch (2.5cm) strip on the bag side to the inside of the bag.

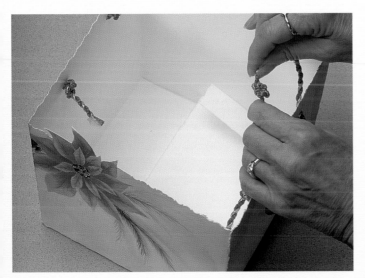

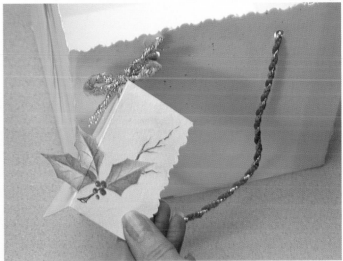

30 Punch holes in the bag sides on the penciled Xs. (Refer to the schematic diagram on page 45 if necessary.) Thread one end of a 25-inch (63.5cm) decorative cord through a bag hole, tying a knot inside the bag at the end of the cord. Do the same with the remaining cord ends and bag holes to create two handles.

Before tying off the last knot, you may want to string on the gift tag through a hole punched near the back right corner. Another method of attaching the tag is described in the next step. Trim any excess cord at the knots.

31 Punch a hole in the back right corner of the gift tag. Thread a 9-inch (22.9cm) decorative cord through the hole and tie the ends around one handle in a bow.

Turn the page to see the completed bag.

COMPLETED GIFT BAG

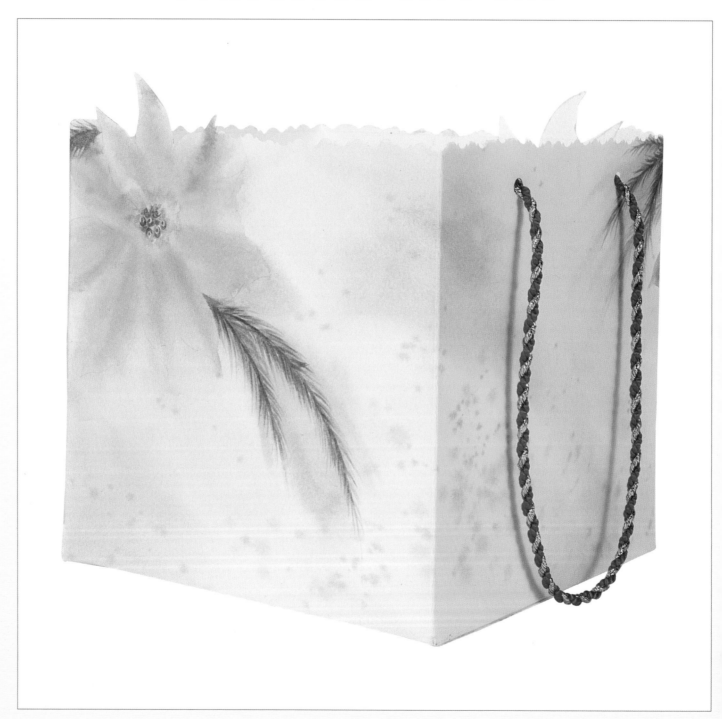

SOFT-LOOK POINSETTIA VIEW

COMPLETED GIFT BAG AND TAG

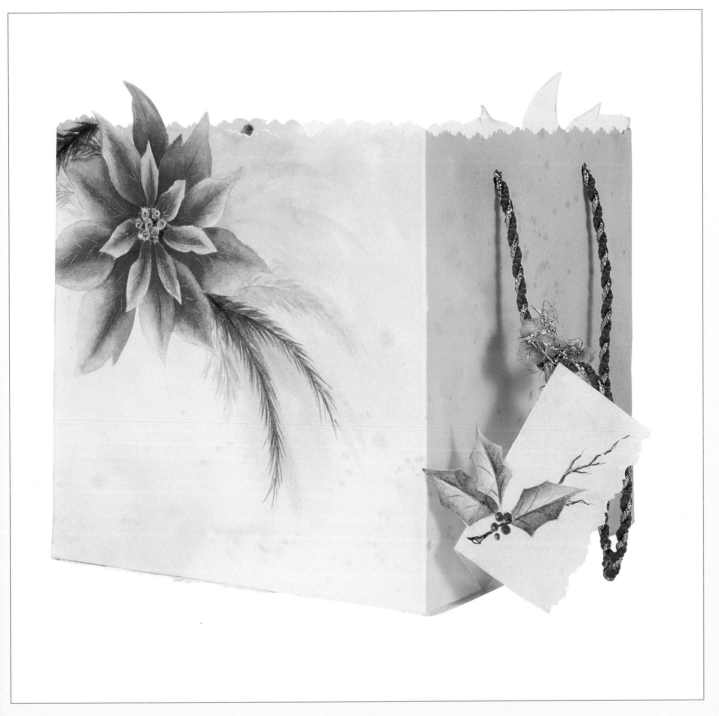

DEFINED-LOOK POINSETTIA VIEW

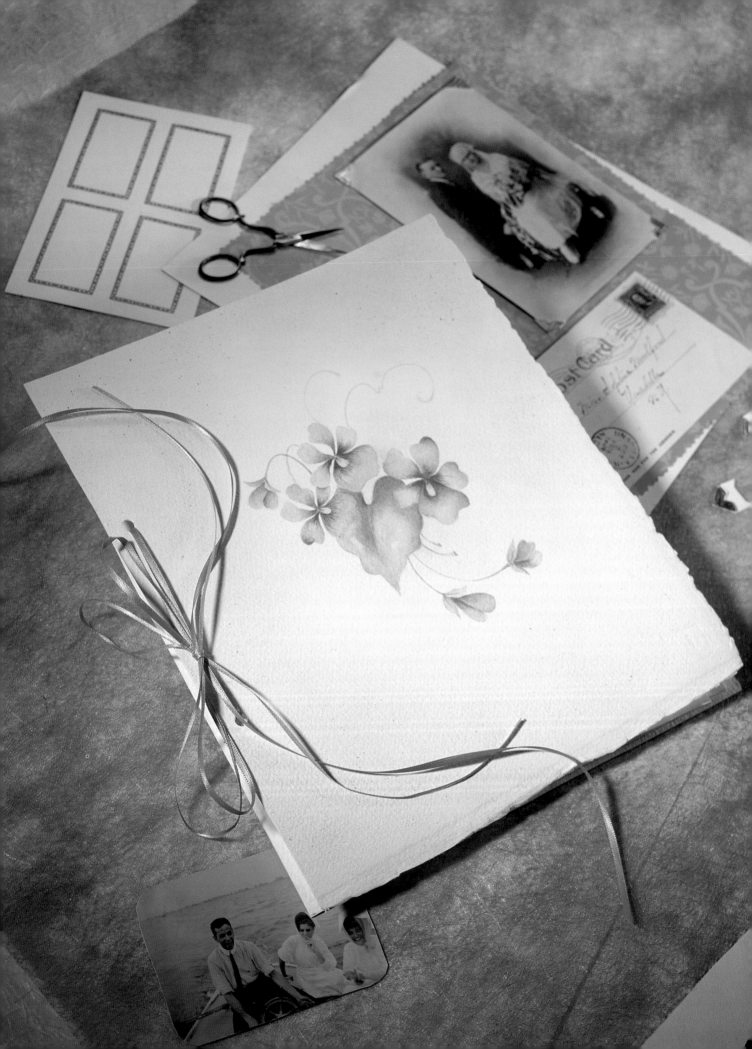

Violets on a Memory Album

Paint: WINSOR & NEWTON ARTISTS' WATER COLOURS

GOLD OCHRE

ALIZARIN CRIMSON

You will also need these colors, which are used in the mixes:
French Ultramarine, Viridian.

Mixes

LV. RED VIOLET*:
ALIZARIN CRIMSON +
FRENCH ULTRAMARINE +
DOT OF GOLD OCHRE

DV. RED VIOLET*:
ALIZARIN CRIMSON +
FRENCH ULTRAMARINE +
DOT OF GOLD OCHRE

LV. BLUE VIOLET*:
FRENCH ULTRAMARINE +
ALIZARIN CRIMSON +
DOT OF GOLD OCHRE

DV. BLUE VIOLET*:
FRENCH ULTRAMARINE +
ALIZARIN CRIMSON +
DOT OF GOLD OCHRE

LV. GREEN*:
VIRIDIAN + RED
VIOLET

DV. GREEN*:
VIRIDIAN + RED
VIOLET

* The light values have more water than the dark values.

This album cover was designed for the 90th birthday of a very special lady—my mother-in-law. Her daughter had asked everyone to send a card recalling an event shared with her mother. As I wondered what to do for a gift, I realized a handmade album would give my mother-in-law a lovely way to organize her cards.

I chose violets because they were not only her favorite flower, but also the flower for February, her birth month.

M A T E R I A L S

Surface

Arches 300-lb. (640gsm) watercolor paper:
 cold-pressed
 11½" x 9½" (29.2cm x 24.1cm)

Royal Majestic Brushes

- no. 1 liner
- no. 6 round
- no. 8 round
- 1-inch (25mm) flat wash

Additional Supplies

- square doily
- toothbrush
- paper towel
- paper punch
- paper for album pages
- 1 yard (91.4cm) of ⅛-inch (3mm) lavender ribbon
- 1 yard (91.4cm) of ⅛-inch (3mm) rose ribbon

Pattern

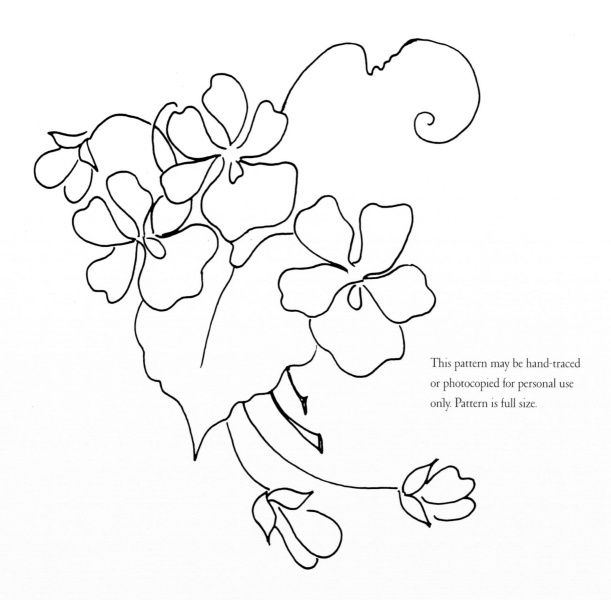

This pattern may be hand-traced
or photocopied for personal use
only. Pattern is full size.

Back Cover

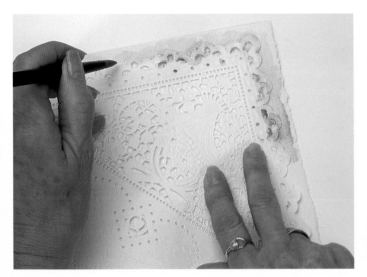

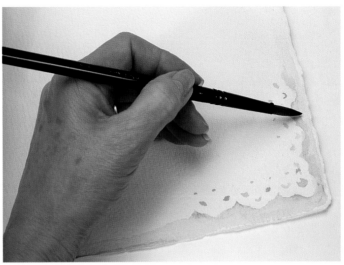

1 Start with the back cover, which allows you to check your colors. Do not tape your watercolor paper to your painting board, or you will have a white edge on your album cover. Place the corner of your doily about 1/4" (6mm) from the top right corner edges of a 9 1/2" x 11 1/2" (24.1cm x 29.2cm) sheet of 300-lb. (640gsm) Arches watercolor paper. Using lv. Red Violet, lv. Green and lv. Blue Violet on a no. 8 round, apply each color separately and randomly. Push the color away from the doily edge and dab it into the holes. See page 30 for more information about this doily technique.

2 Repeat step 1 on the lower right corner. Remove the doily and soften the outer edges of both corners with the no. 8 round.

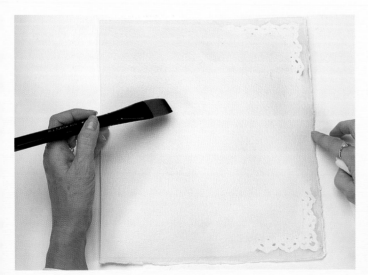

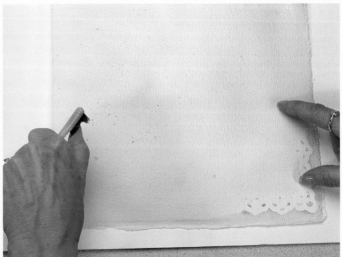

3 Dampen the unpainted portion of the cover with a 1-inch (25mm) flat brush. Using the same brush, randomly slip-slap areas of lv. Red Violet, lv. Blue Violet and lv. Green to create large mottling.

4 Apply speckles of lv. Blue Violet with a toothbrush, as explained on page 27.

Front Cover Background

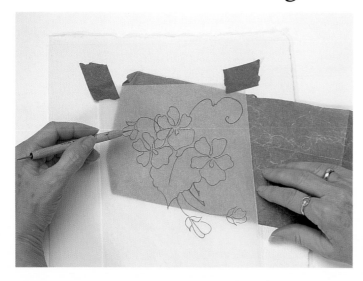

5 Place your pattern so the bud furthest to the left is 2 3/4" (7.0cm) from the left edge of the other sheet of watercolor paper and the uppermost violet is 3" (7.6cm) from the top edge of the watercolor paper. Secure the pattern at the top with painters' tape. Transfer the pattern as explained on pages 18-19.

6 Again, to avoid a white edge on the album cover edges, do not secure the watercolor paper to your painting board. Dampen the album front cover around the violets with the 1-inch (25mm) flat brush. Apply the mottling as you did in step 3, but do not speckle. Push the color into the crevices of the violet pattern so you won't have hard edges. If the paper rises, hold it down in the center with your fingers. Let dry.

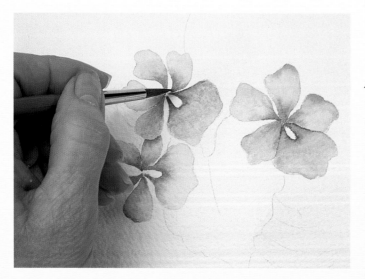

7 Now you can tape the watercolor paper to your painting board. Painting wet-on-dry and using the no. 6 round, apply a basecoat of lv. Red Violet to one entire pink violet petal without reloading the brush. Add shading of dv. Red Violet to the same petal, letting the color bleed to soften the edges. Paint all the pink violet petals in the same manner, turning the painting board so the shading will flow from the darker area to the lighter. Then paint the lavender violet in the same manner, using lv. Blue Violet for the basecoat and dv. Blue Violet for the shading.

Hint

When shading or tinting an area, flatten your round brush and gently work on the hard edge of color. This should produce a softer effect.

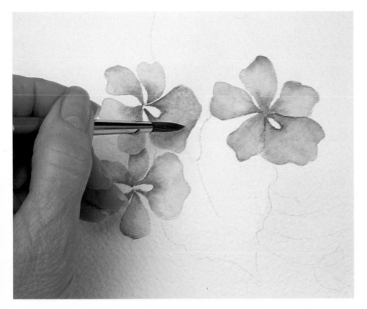

8 Painting wet-on-dry, use the no. 6 round to apply a tint of lv. Red Violet to the edge of a lavender violet. Rinse and flatten the brush to soften the edges of the tint. Add a little color if necessary. Work one petal at a time until both lavender violets are tinted. Then add tinting to the pink violet petals in the same manner, except using lv. Blue Violet.

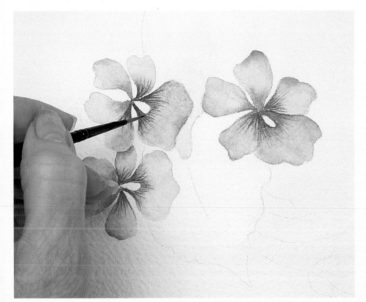

9 With the no. 6 round, add lv. Green between the lavender and the pink violets to make the background more interesting.

Using the no. 1 liner, paint lines of dv. Blue Violet on the bottom three petals of both lavender flowers. Turn your board so you'll always be pulling from the flower center outwards. Using dv. Red Violet, paint lines on the pink violet in the same manner.

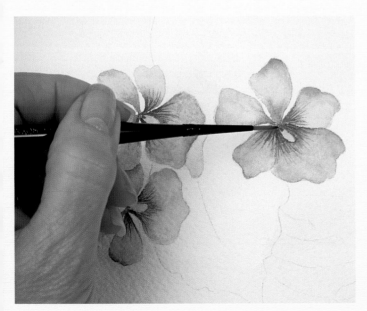

10 Using the no. 6 round, paint a wash of Gold Ochre on all three flower centers. Then apply a dot of Gold Ochre to the base of each flower center, letting it flow down. Let the centers dry, and then add a dot of Alizarin Crimson to the base of each center with a no. 1 liner.

Buds

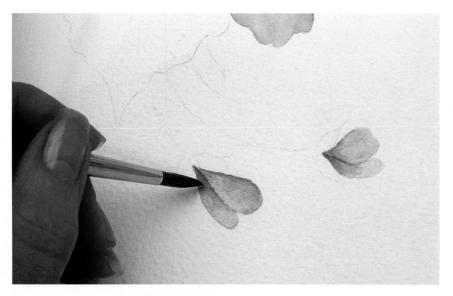

11 Using the no. 6 round, base the buds, some in lv. Red Violet and some in lv. Blue Violet. To keep the colors from bleeding, avoid painting a bud adjacent to a wet bud. This photo shows the two bottom buds on the right. The third bud on the upper left should also be painted.

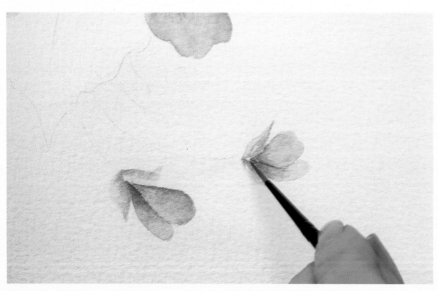

12 Basecoat the bud sepals with lv. Green on a no. 1 liner. Shade with dv. Green.

Hint

To form a good point on your liner, roll the brush in the paint as you load.

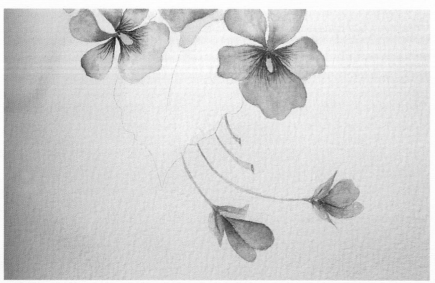

13 With a fluid consistency of lv. Green, paint the bud stems, always pulling toward yourself. Add dv. Green to the stems as they come out from under the leaf. Add the same color to the two stem ends. Again with the same color, add sepal veins.

Leaf and Tendrils

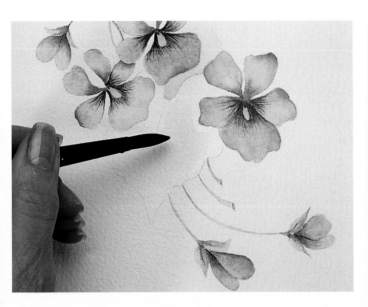

14 Dampen the right side of the leaf and apply a wash of Gold Ochre to the middle with a no. 8 round.

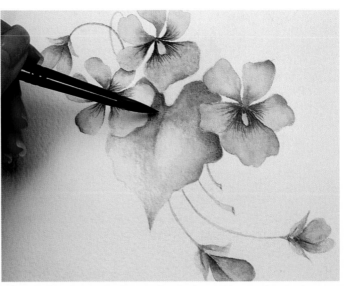

15 After the Gold Ochre dries, neatly wet the entire leaf with a no. 8 round and apply a basecoat of lv. Green, letting some Gold Ochre show through in the center. For shading, apply dv. Green. You can keep working the colors until the paper starts to dry. If more shading is needed, let the surface fully dry and apply more paint, using the wet-on-dry technique.

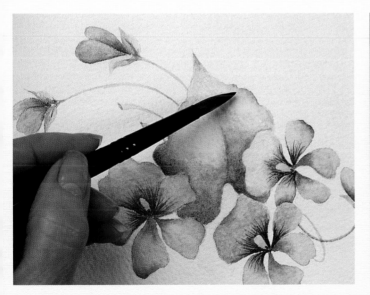

16 To tint the leaf, apply lv. Blue Violet on the left edge, using the wet-on-wet method. Turn the paper so you can pull in and down.

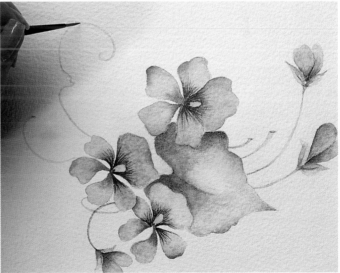

17 Pull the tendrils with lv. Green on a no. 1 liner, using fluid paint.

Finishing

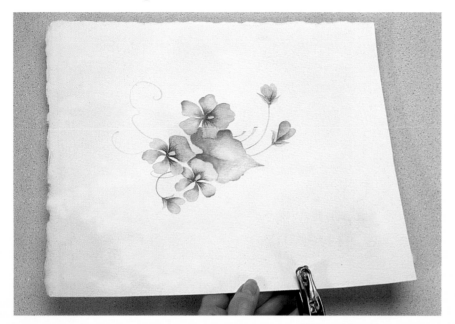

18 Lay a paper towel over the center design and, using the technique demonstrated in step 4, speckle the cover with dv. Green. Repeat with dv. Blue Violet.

 Punch two holes on the binding side of each cover. Place one hole 3" (7.6cm) from the top and another 3" (7.6cm) from the bottom. Both holes should be ¹⁄₂" (1.3cm) in from the edge.

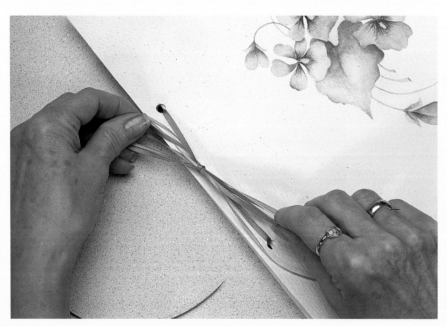

19 Punch your album pages to line up with the covers. Then thread the two ¹⁄₈-inch (3mm) ribbons through the holes and tie in a bow.

Hint

If your album cover dries warped, stack books on top of it for several days. If it still hasn't flattened out, you can lightly wet down the unpainted side and reshape.

COMPLETED VIOLET MEMORY ALBUM

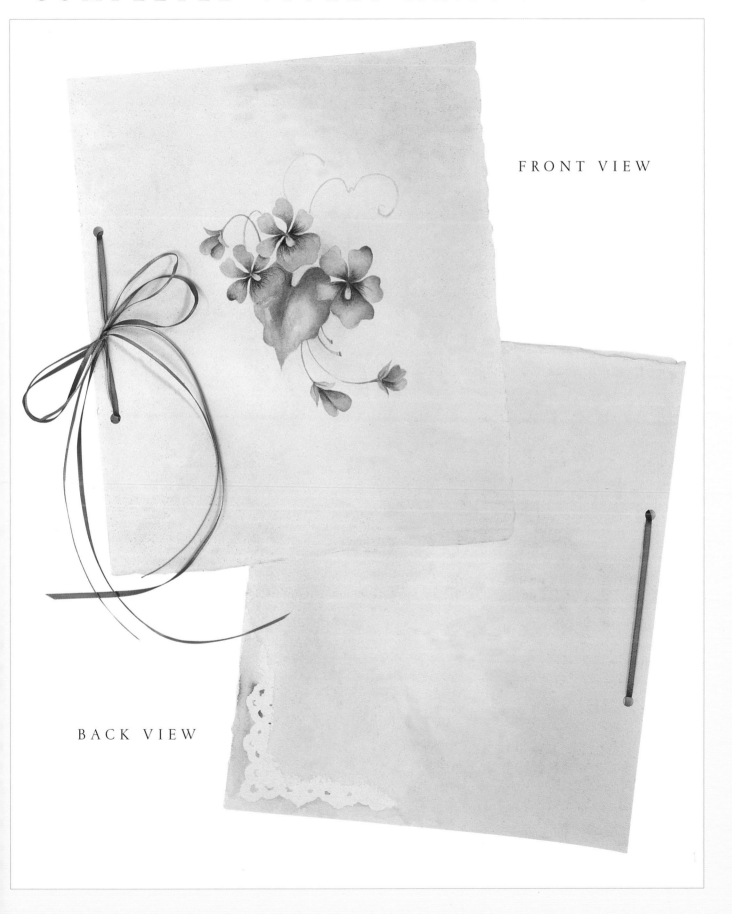

FRONT VIEW

BACK VIEW

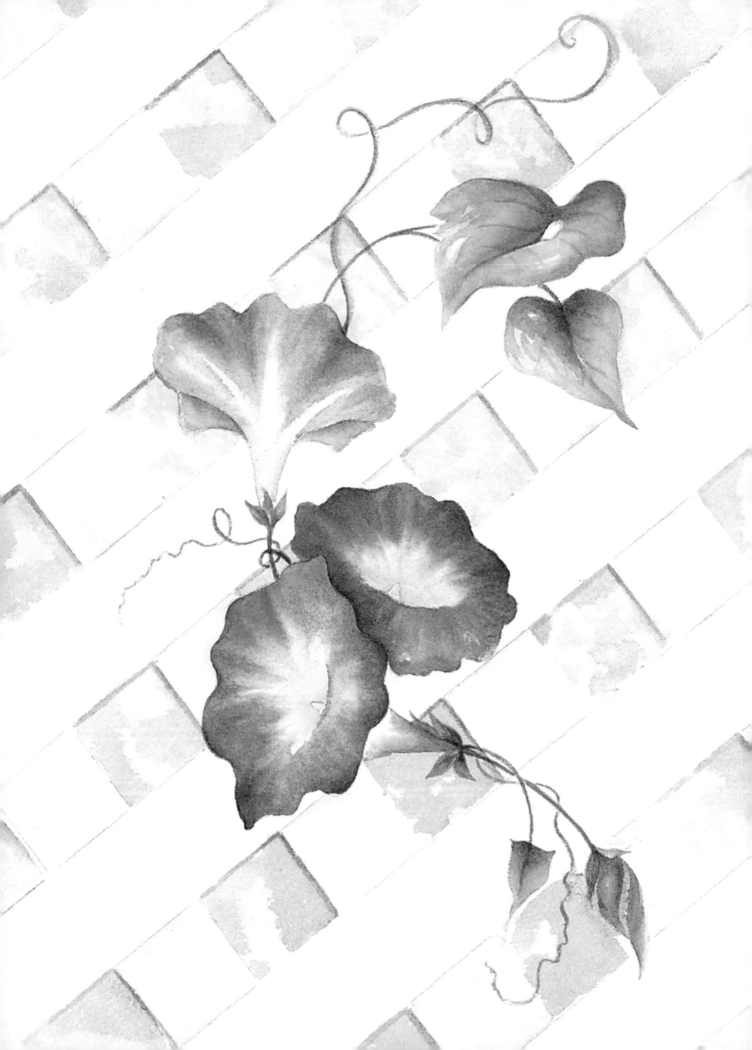

Morning Glories on a Trellis

Paint: WINSOR & NEWTON ARTISTS' WATER COLOURS

NEW GAMBOGE

GOLD OCHRE

You will also need these colors, which are used in the mixes:
Cobalt Blue, Antwerp Blue, French Ultramarine, Alizarin Crimson,
Winsor Violet Dioxazine, Hooker's Green, Ivory Black.

In this painting, strips of tape block out color to create a trellis. Taping could also be used to block out trees, houses, fences or anything with a rigid edge you want to remain white while doing a background.

The soft flow of the S-shaped floral against the angular background may bring other designs to mind that you would like to try.

Mixes

LV. BLUE GRAY*:
COBALT BLUE + IVORY
BLACK

LV. BLUE VIOLET*:
ANTWERP BLUE +
WINSOR VIOLET
DIOXAZINE

LV. VIOLET*:
FRENCH ULTRAMARINE +
WINSOR VIOLET
DIOXAZINE +
DOT OF GOLD OCHRE

LV. RED VIOLET*:
ALIZARIN CRIMSON +
WINSOR VIOLET
DIOXAZINE + DOT OF
EITHER GREEN MIX TO
TONE

WARM GREEN:
NEW GAMBOGE +
COBALT BLUE

COOL GREEN:
WARM GREEN +
COBALT BLUE +
HOOKER'S GREEN

* Continue to add water until you achieve the desired light value.

M A T E R I A L S

Surface

Arches 140-lb. (300gsm) watercolor paper:
 cold-pressed
 10¼" x 8" (26.0cm x 20.3cm)

Royal Majestic Brushes

• no. 4 round
• no. 6 round
• no. 8 round

Additional Supplies

• Scotch Safe-Release Painters' Masking Tape, 1-inch (2.5cm) width
• ruler
• soft lead pencil
• paper towel
• plastic eraser
• cotton swabs

Pattern

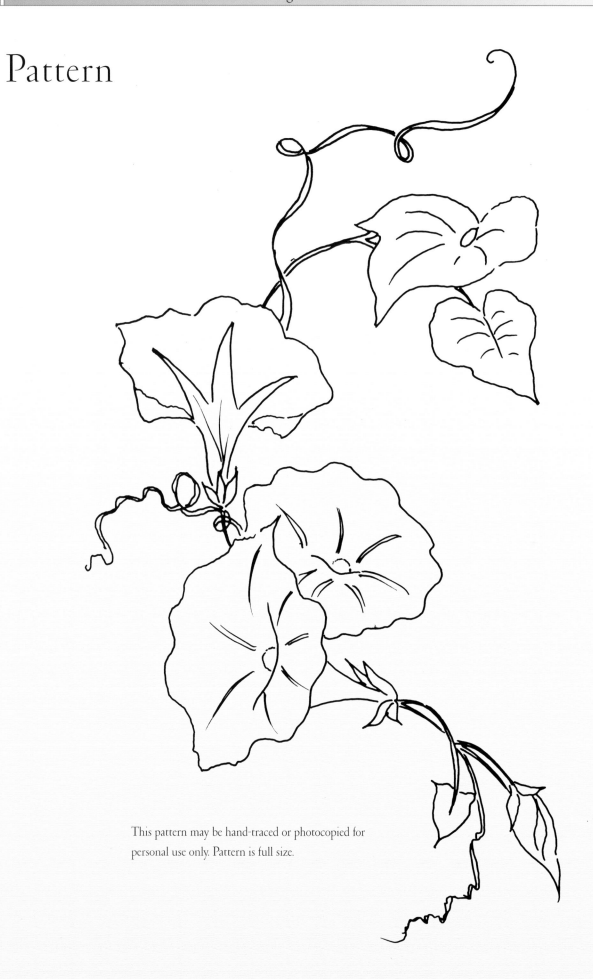

This pattern may be hand-traced or photocopied for personal use only. Pattern is full size.

Masking and Trellis

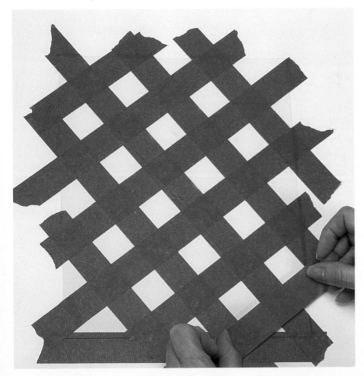

1 Transfer the pattern as explained on pages 18-19. At this point, the outlines of the leaves and flowers are enough.

Tape the bottom only of the watercolor paper to the painting board (see page 17).

Apply a strip of 1-inch (2.5cm) Painters' Masking Tape diagonally from the upper left corner to the bottom right corner of your watercolor paper. Press hard to remove air bubbles. Continue adding parallel strips of tape on both sides of the first strip at 1-inch (2.5cm) intervals.

Apply tape diagonally at a 90° angle from the first tape strips. Begin with the middle strip, starting at the lower left corner. (Because of the 90° angle, this strip will not go to the upper right corner.) Continue adding strips on either side at 1-inch (2.5cm) intervals.

Hint

Painters' Masking Tape isn't as sticky as ordinary masking tape, so it won't rip the paper fibers when removed.

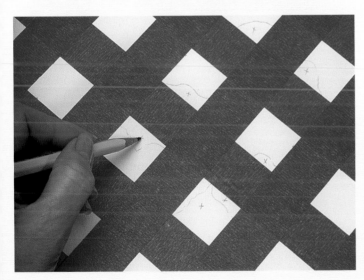

2 In the squares with pattern lines, mark an "X" with a soft lead pencil to indicate which portion will be part of the painted design. This will help avoid confusion when painting.

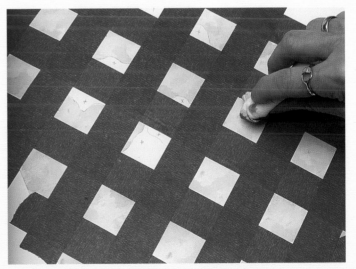

3 With a no. 8 round, paint the whole squares and the portions of the squares without Xs with lv. Blue Gray. Blot with a paper towel to create a mottled effect as you are working. Let the paint dry and then erase the Xs with a plastic eraser. Remove the tape.

Trellis, continued

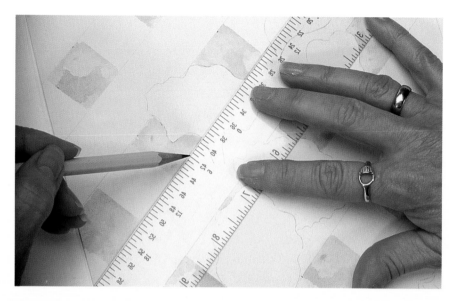

4 Starting at the upper left, lightly pencil in lines across the tops and bottoms of the rows of painted and unpainted squares. Draw your parallel lines only in the direction you see in the photo. This determines which trellis slats will be on top.

5 Using a no. 8 round, apply lv. Blue Gray to create shading at the tops and bottoms of the non-mottled squares, dampening each square as you go. Apply the shading color and then soften to the middle of the squares.

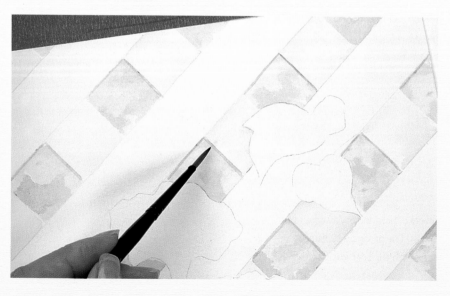

6 Using a no. 4 round, apply shading lines of lv. Blue Gray to the tops and right sides of the mottled squares. This represents the thickness of the wood.

Morning Glories and Bud

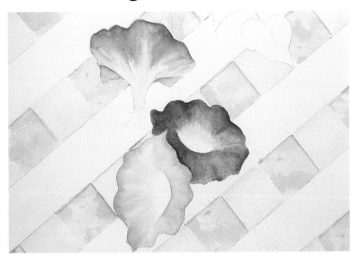

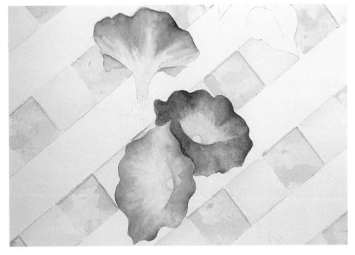

7 Finish transferring the pattern. You will paint the morning glories one at a time, wet-on-wet. Leave the centers of the outward-facing flowers and the three light-colored "fingers" of the inward-facing flower dry. Use lv. Violet on the top and bottom flowers and lv. Blue Violet on the middle flower.

With a no. 8 round, apply paint to the outside edge of the petals. Pull the color toward the center. While the paint is still wet, apply additional shading. On the two outward-facing flowers, apply a thin "smile line" along the edge crossing the stamen. Pull the color down into the petal.

Repeat all the coloring and shading as necessary to intensify colors. Be sure not to paint two adjoining wet areas. In this photo, the middle and top flowers have additional layers, but the bottom flower still has only one.

8 With the no. 8 round, apply tints of lv. Red Violet to the outward-facing flowers. With the no. 6 round, dampen the inside areas of the outward-facing flowers. Then apply New Gamboge next to the smile line, pulling the color away from the center. Dry and then shade with Gold Ochre around the stamen.

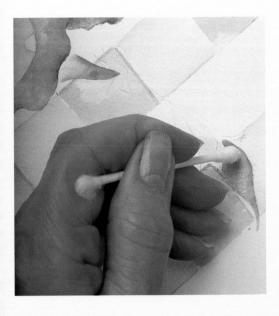

9 (left) Using a wet-on-wet technique with lv. Violet on a no. 6 round, paint the trumpet of the bottom flower, starting at the point and pulling color up the two sides.

With lv. Red Violet on a no. 6 round, basecoat the bud, wet-on-wet. Then with a cotton swab, create an S-stroke highlight.

10 (right) With the no. 6 round, apply lv. Violet shading on either side of the bud highlighting and at the bud base.

This photo also shows the first stages of painting the leaves and sepals. The process is explained fully with the large leaves in the next two steps.

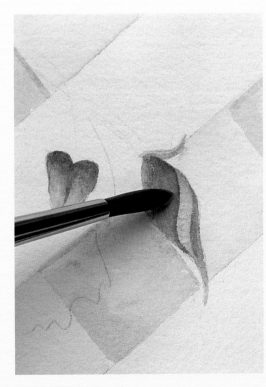

Leaves, Sepals and Tendrils

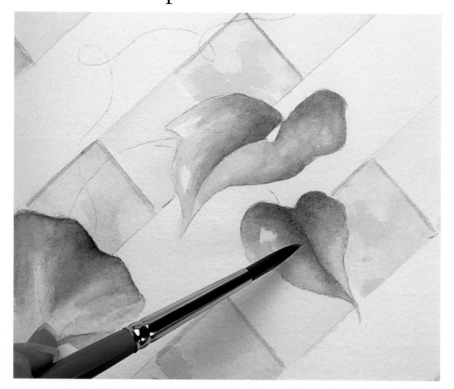

11 Basecoat all the leaves and sepals in Warm Green with a no. 6 round, wet-on-wet. For the larger leaves at the top, dampen, leaving random spots. These spots of dry paper will purposely be left white for interest. Next apply Cool Green shading, wet-on-dry, softening outward from the center vein.

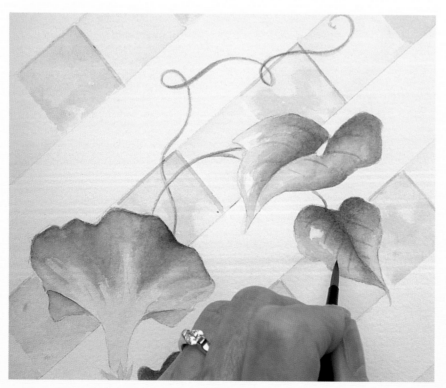

12 With Warm Green on a no. 6 round, pull all the stems and tendrils. Repaint here and there with Cool Green, taking care to darken where they come out from under the leaves or another part of the tendril.

Paint the veins of the top leaves with Cool Green on a no. 4 round, pulling from the center outwards.

COMPLETED MORNING GLORIES

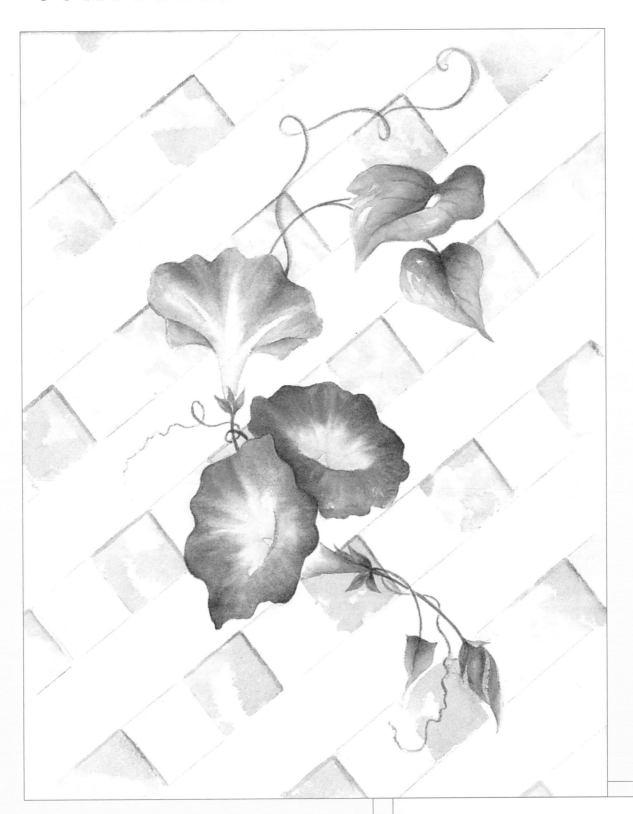

FRAMING TIP

Matting—even without a frame—makes all the difference in the world. Never give up on a painting until you mat it. And always use an acid-free mat.

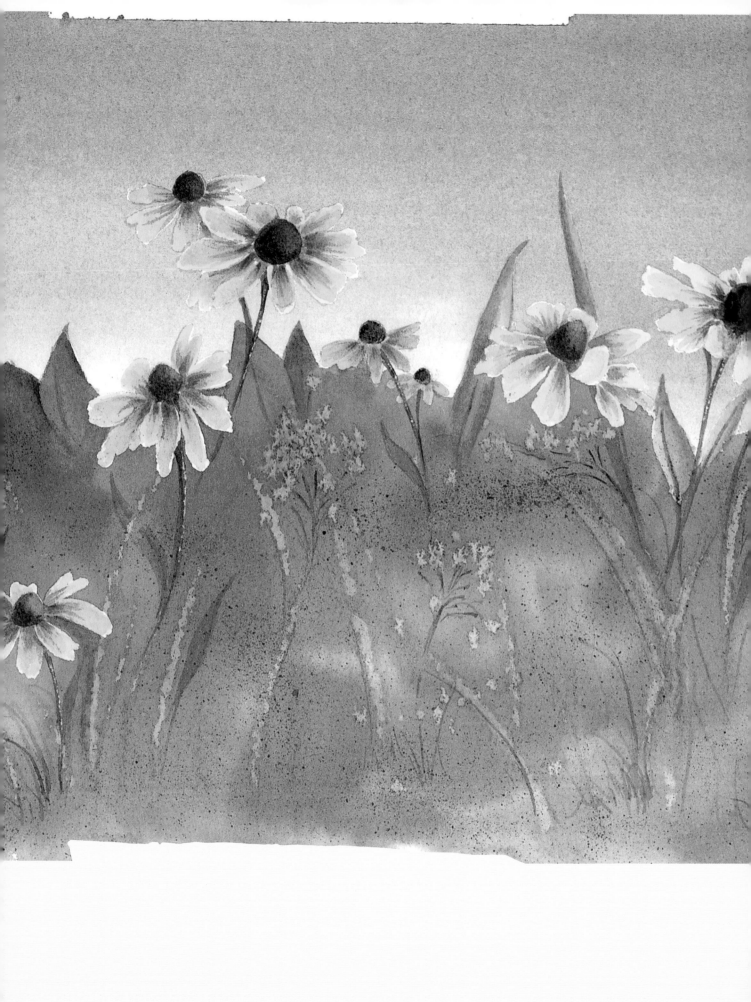

Black-eyed Susans

Paint: WINSOR & NEWTON ARTISTS' WATER COLOURS

AUREOLIN

NEW GAMBOGE

CADMIUM ORANGE

GOLD OCHRE

ALIZARIN CRIMSON

BURNT UMBER

IVORY BLACK

You will also need these colors, which are used in the mixes below: French Ultramarine, Hooker's Green, Burnt Sienna.

My black-eyed Susan painting was inspired by a photo shot on Block Island in New England. The strong contrast of the flowers against the sky and dark foliage make an impact.

This project gives you a chance to strengthen familiar techniques while learning new ones. Sprinkled salt is used to form Queen Anne's lace. Grass and leaves are formed with the beveled end of a brush on wet paper. Highlights are scraped in with a craft knife. Toothbrush speckling adds interest and texture to the foreground.

Mixes

DARK BLUE:
FRENCH ULTRAMARINE +
IVORY BLACK

DARK GREEN:
HOOKER'S GREEN +
IVORY BLACK

BURNT ORANGE:
BURNT SIENNA +
ALIZARIN CRIMSON

DARK BURNT ORANGE:
BURNT UMBER +
ALIZARIN CRIMSON

M A T E R I A L S

Surface

Arches 140-lb. (300gsm) watercolor paper:
cold-pressed
6½" x 10" (16.5cm x 25.4cm)

Royal Majestic Brushes

• no. 4 round
• no. 6 round
• 1-inch (25mm) flat wash

Additional Supplies

• masking supplies: Winsor & Newton Art Masking Fluid,
 no. 2 round, soap, extra tub of water, rubber cement eraser
• kosher salt
• beveled-handle brush
• paper towel
• toothbrush
• craft knife

Pattern

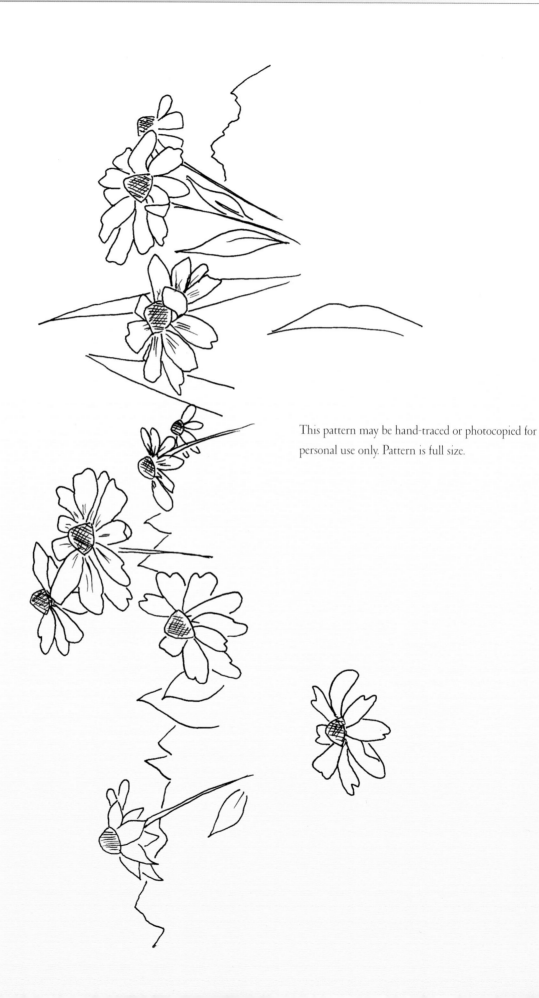

This pattern may be hand-traced or photocopied for personal use only. Pattern is full size.

Masking, Sky and Special Effects

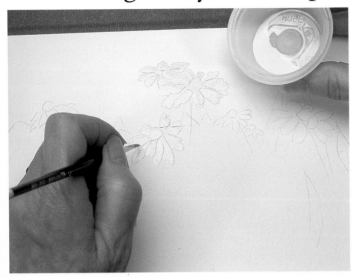

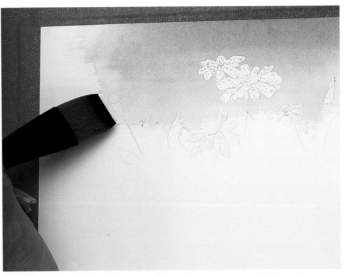

1 Tape down your watercolor paper and transfer the pattern (see pages 17-19). Prepare a no. 2 round masking brush and mask out the black-eyed Susans carefully, as if you were painting. Also mask the leaf and grass tips that extend into the sky. Let the masking fluid dry.

2 Wet the sky area with a 1-inch (25mm) flat. Wait until your paper has a nice sheen and then wash on Dark Blue. Keep the color a little darker at the top, lightening as you go down. Paint right over the masking fluid to keep your strokes long and smooth. Let dry.

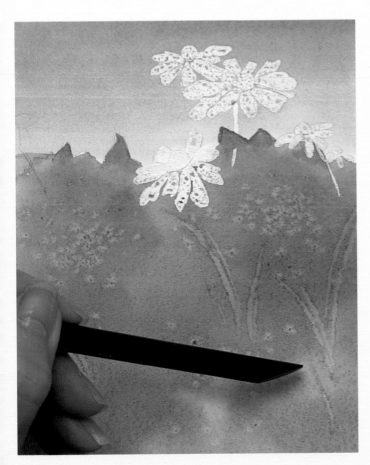

3 Erase the masking fluid from the tips of the leaves with a rubber cement eraser. With your 1-inch (25mm) flat, carefully wet the grass area, keeping in mind that if you get water on the dry sky area, the grass color will flow there. With Dark Green, use a slip-slap motion to get light and dark grass areas.

Sprinkle a little kosher salt here and there to get a Queen Anne's lace effect. At this point you will use the end of a beveled-handle brush to scrape curved lines in the wet paint. You might want to practice scraping these curved lines on a spare piece of watercolor paper before you scrape your painting. When scraping, you will actually be damaging the paper, making grooves and pulling paint away to create a grass-and-leaves effect.

When the area is completely dry, brush off the salt crystals with your hand.

More information on these pages

Masking. 31

Salt sprinkling. 28

Beveled-handle brush scraping. 32

Black-eyed Susans

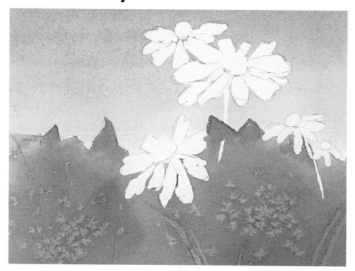

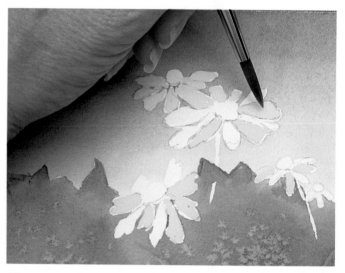

4 Erase the remaining masking fluid. Use your pattern to retrace the flower petals.

5 With Aureolin on a no. 6 round, basecoat the flower petals that overlap others, wet-on-dry.

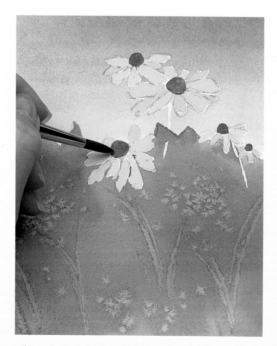

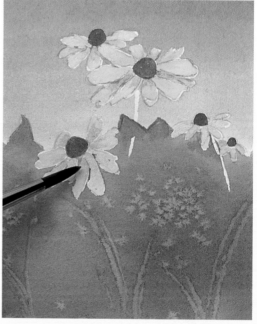

6 Using the same brush, basecoat the remaining petals in New Gamboge, wet-on-dry. Basecoat the flower centers with Burnt Umber.

7 For the next two steps you will be building color by glazing with a no. 6 round. Start by applying New Gamboge to the lighter petals and pulling them out. Then apply Gold Ochre to the darker petals, always working from the center out.

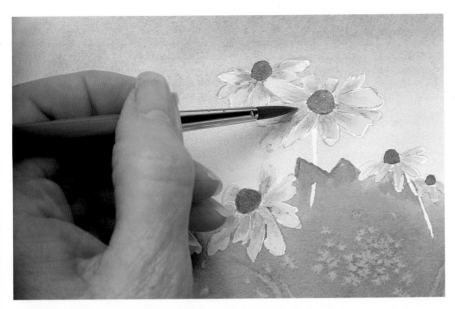

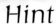*8* Pull out streaks of Cadmium Orange. Add some Burnt Orange streaks, being careful not to completely cover the Cadmium Orange.

Hint

Rather than trying to achieve the exact look you see here, strive for an effect that pleases you. Remember that every flower is different and watercolors never go on the same way twice. Variety, variety, variety!

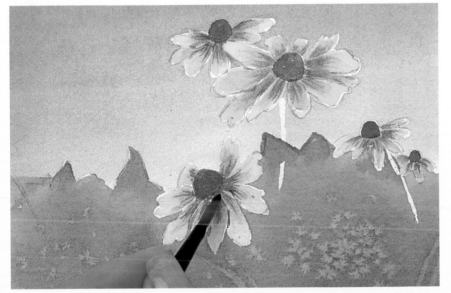

9 Still working wet-on-dry, with Dark Burnt Orange on the no. 4 round, pull a few streaks from the base of the petals outwards. Because you're using a smaller brush, these streaks will appear more distinct.

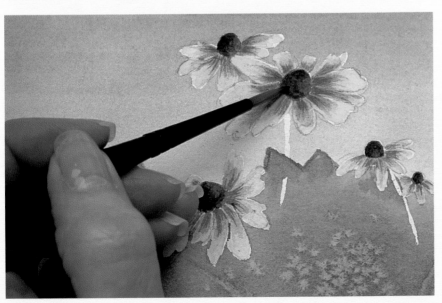

10 To help create a focal point, add some Alizarin Crimson to the petals of the central flowers, making these a bit more intense. Rebase the centers with Burnt Umber, starting on the left so the color will be more intense there. Then add a touch of Ivory Black on the left side of the centers. At this point you are essentially finished with the flower heads, but you may want to touch them up. Go for an effect that pleases you, but don't overwork.

Grass, Leaves and Stems

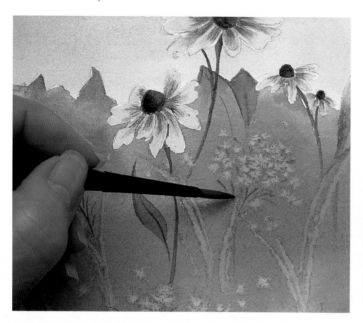

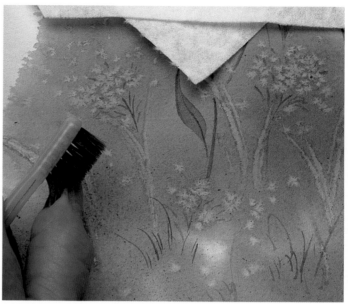

11 With Dark Green on a no. 4 round, pull down the black-eyed Susan and Queen Anne's lace stems. Remember to include stem lines within the Queen Anne's lace flower heads. Also paint in some freehand leaves. Add some leaf veins and grass blades.

12 Next comes speckling. Cover the sky and flowers with a paper towel. Load a toothbrush with Dark Green. Test speckling on an extra piece of paper, and then apply it to your painting.

More information on these pages

Toothbrush speckling 27

Craft knife highlighting 33

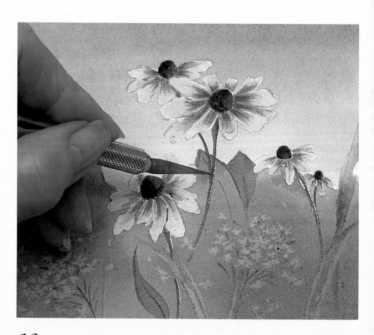

13 For stem highlights, scrape the paper with a craft knife. Use a series of short strokes rather than trying to highlight in one long stroke.

COMPLETED BLACK-EYED SUSANS

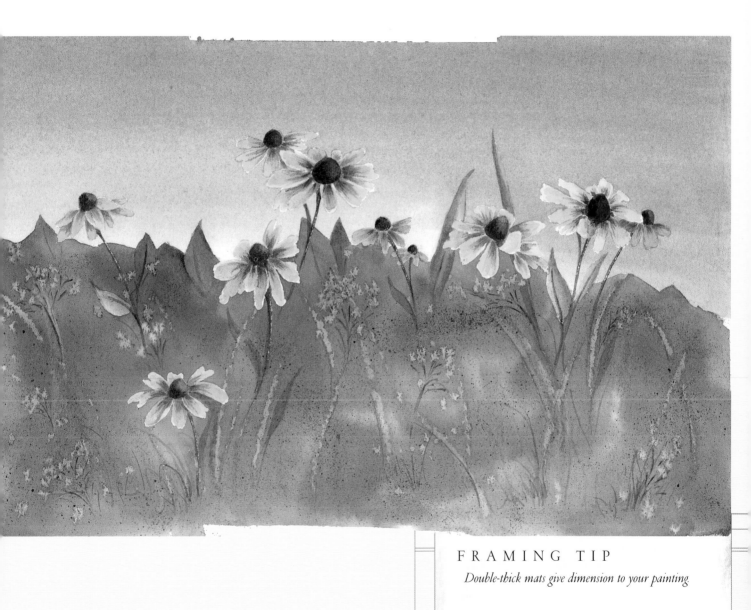

FRAMING TIP
Double-thick mats give dimension to your painting.

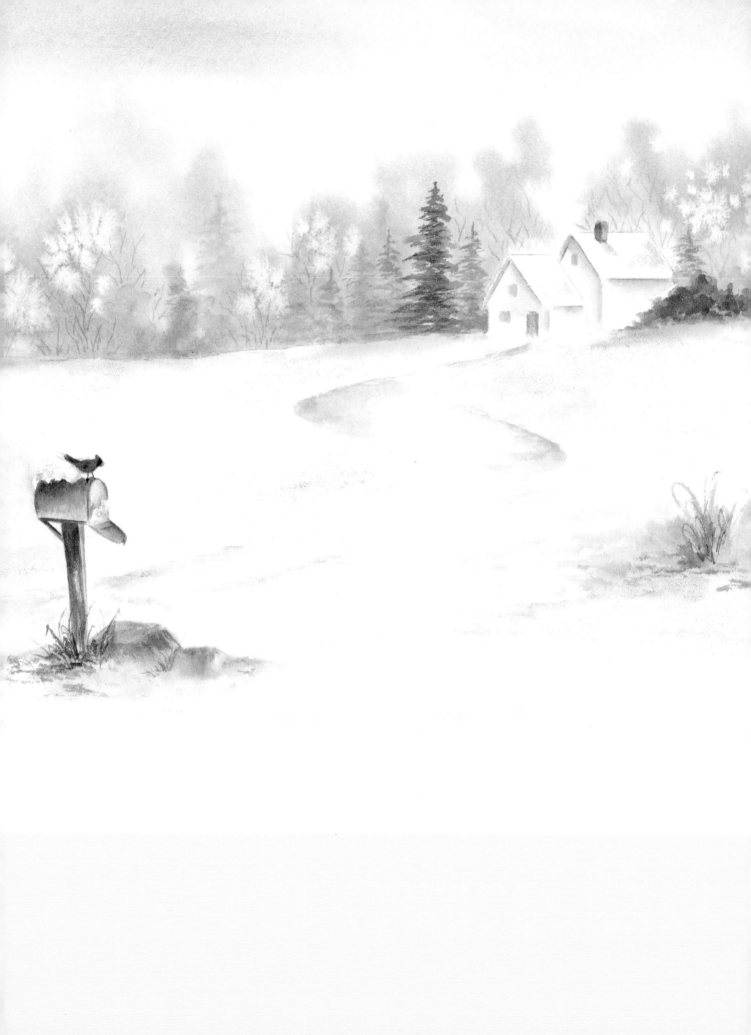

Winter Landscape

Paint: WINSOR & NEWTON ARTISTS' WATER COLOURS

NEW GAMBOGE

COBLT BLUE

ALIZARIN CRIMSON

WINSOR VIOLET
DIOXAZINE

PAYNE'S GRAY

BURNT UMBER

IVORY BLACK

You will also need Hooker's Green, which is used in a mix.

This beginner landscape gives you practice painting a graduated sky. Soft background trees with a special salt effect add interest and texture.

Don't worry about getting these techniques exactly right. If you judge them unsuccessful, you can pull the picture back together with the more controlled washes used in shading the house and the mailbox with the bird. Since the bird is the focal point of the picture, it should draw your eye down, away from the tree line. The sparkling snow effect created by the iridescent medium is forgiving as well as fun. It can calm the value of the green trees if they're too bright. Remember, your project is just paint on paper. Relax and enjoy.

Mixes

PURPLE: WINSOR
VIOLET DIOXAZINE +
PAYNE'S GRAY

RUST:
ALIZARIN CRIMSON
+BURNT UMBER +
DOT OF PAYNE'S GRAY

GREEN:
HOOKER'S GREEN +
PAYNE'S GRAY

DV. BROWN:
BURNT UMBER +
DOT OF PAYNE'S GRAY

MATERIALS

Surface
Arches 140-lb. (300gsm) watercolor paper:
 cold-pressed
 8" x 12" (20.3cm x 30.5cm)

Royal Majestic Brushes

• no. 1 liner
• no. 4 round
• no. 6 round
• no. 8 round
• ¼-inch (6mm) angle
• 1-inch (25mm) flat wash

Additional Supplies
• kosher salt
• paper towel
• Winsor & Newton Iridescent Medium
• old round brush for applying Iridescent Medium

Pattern

This pattern may be hand-traced
or photocopied for personal use
only. Enlarge at 112% to bring up
to full size.

Background

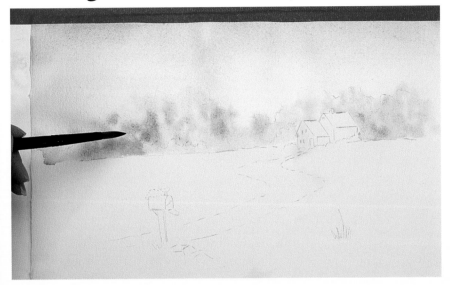

1 Tape down your watercolor paper and transfer the pattern (see pages 17-19). The painting for steps 1 through 6 should be done quickly, wet-on-wet, so you may want to read through those instructions before starting.

With a 1-inch (25mm) flat brush, dampen your paper from the top to the horizon. Do not dampen the house. Still using the 1-inch (25mm) flat, brush in a band of Cobalt Blue sky, working it down to the horizon. Using the no. 8 round, dab in splotches of Purple, Green, Payne's Gray and Rust, creating shadowy trees.

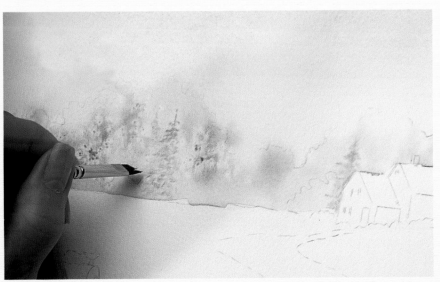

2 Sprinkle kosher salt over the colors near the horizon. This will give a mottled effect. (You'll brush off the excess salt in step 6.)

3 Using a ¼-inch (6mm) angle brush with Payne's Gray, paint a few pine trees where the paper is more wet. This will allow the color to bleed a bit.

Background, continued

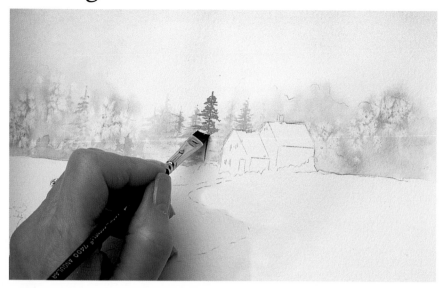

4 As the paper begins to set up, add a few more pines in Green, still using the ¹/₄-inch (6mm) angle brush.

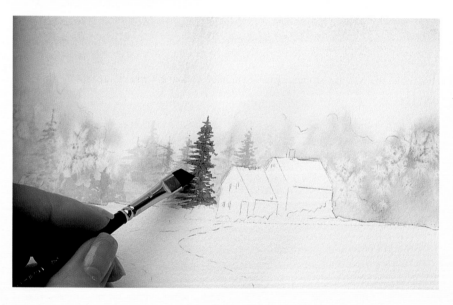

5 For the darkest tree, start with a medium value of Green. With the point of your angle brush, paint the center tree line. Rocking the edge of the brush back and forth, paint a small triangle of branches at the top of the tree. Then add another slightly larger triangle below the first. Continue to work down the line with triangles. Add shading and fill in spaces with a dark value of the same color.

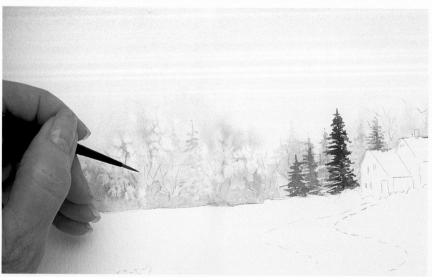

6 After allowing the top portion of your painting to thoroughly dry, brush off the salt with a paper towel. Using a no. 1 liner and Payne's Gray, draw in the fine-line branches of the deciduous trees. The paint should be of ink-like consistency.

House and Path

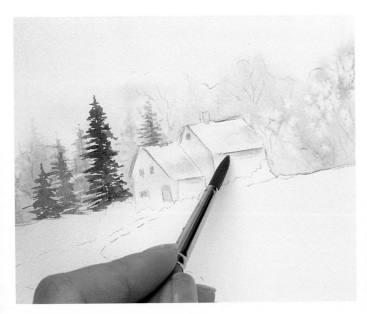

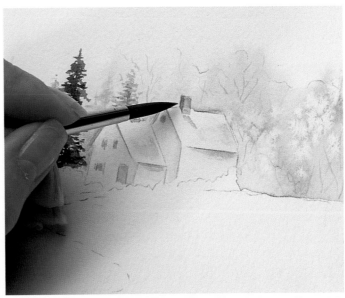

7 Paint the shading on the house, wet-on-dry, with a no. 6 round and various values of Payne's Gray. Move around to different portions so you'll never be painting adjoining wet areas. Pick up a little Winsor Violet Dioxazine for the roof. Doors and windows are a darker value of Payne's Gray.

8 Basecoat the chimney with a light value of Rust on a no. 6 round. Repaint the left side with the same light value, which will create a medium-value shading. Add the chimney shadow in Payne's Gray.

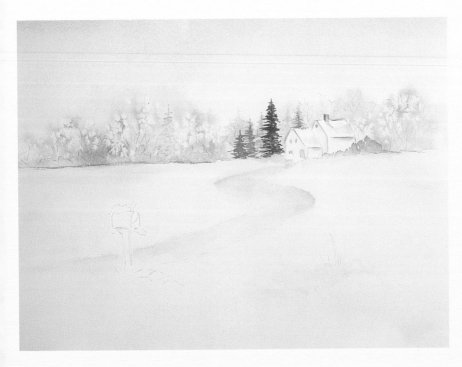

9 Much of the painting below the horizon is done wet-on-wet. Dampen this portion of the paper with a 1-inch (25mm) flat, leaving the mailbox dry. Switch to the no. 8 round. Dab on the basecoat of the bush beside the house with Green. Paint a loose line of Green shading at the horizon line under the trees. Add a soft area of New Gamboge to the bottom foreground to create warmth. To create shading for the snow, add soft areas of Payne's Gray and Purple. Paint the path in horizontal strokes of Payne's Gray, Purple and a touch of Cobalt Blue. You may need to repaint the path as the paper sets up.

Hint

Keep cotton swabs handy to remove extra moisture and color.

Mailbox, Rocks and Grass

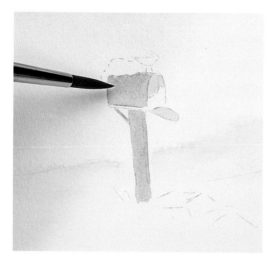

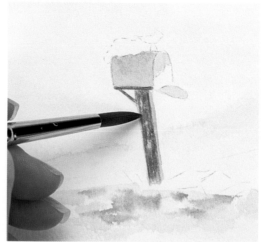

10 Painting wet-on-dry, use the no. 6 round to apply a wash of dv. Brown to the mailbox post. Paint the mailbox, avoiding the snow, with a light-value wash of Payne's Gray.

11 With the no. 6 round, paint a light wash of Burnt Umber under the mailbox. Add a few grasses to the right using this same color, which will serve as a base for the colors you'll add in step 15. (The grass is not shown here. See the completed painting on page 91 for placement.)

Load the brush with dv. Brown and remove some of the moisture from the brush ferrule with a paper towel. Paint the mailbox post, using a dry brush technique, leaving an unpainted slice on the right. Paint in the board and the diagonal wood support under the mailbox.

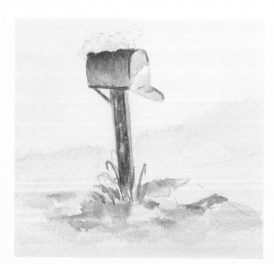

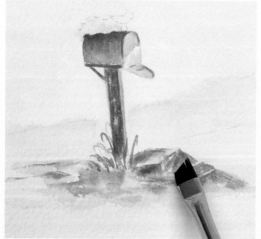

12 With Payne's Gray on a no. 6 round, add shading to the mailbox top. Apply several layers, letting the paint dry between each. Outline the mailbox lid on the right, and then soften with a bit of shading. Add some medium and dark values of Payne's Gray to the top of the rocks. Paint in shading and a few grasses at the base of the mailbox. Add some light-value shading to the snow on top of the mailbox.

13 With dv. Brown on the ¼-inch (6mm) angle brush, pull down a few angular strokes on the rocks. Let a little white from the paper show.

Hint

Always pull grasses from the base up, the way they grow.

Grass, Bushes and Cardinal

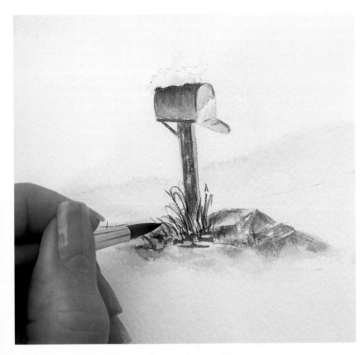

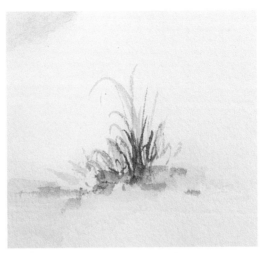

15 Finish the grasses on the right with the no. 6 round. Add a few strokes of Payne's Gray and more strokes of Purple. For shading under these grasses, hold the brush horizontally and dab on some Purple.

14 Finish the grasses under the mailbox with dv. Brown on a no. 6 round.

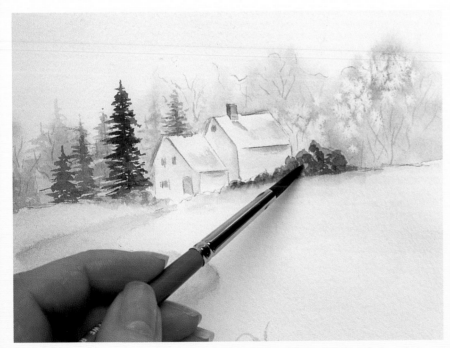

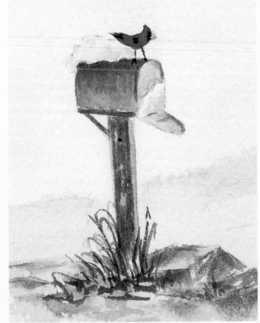

16 Finish the bushes at the side of the house with a dark value of Green on a no. 6 round, dabbing here and there with the brush tip. Soften the color under the bush and the darker trees with a damp brush.

17 Using Alizarin Crimson on a no. 4 round, paint the entire cardinal except the beak. Let dry. Paint the beak with New Gamboge. Let dry. Add a touch of Ivory Black to the cardinal wing area and face. Paint lines for the legs.

Iridescent Medium

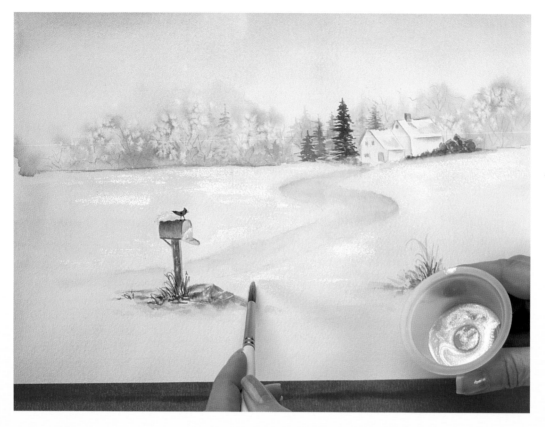

18 Shake a bottle of Winsor & Newton Iridescent Medium to mix it well. Pour a little into a small cup. Spread the Iridescent Medium across the snow with the side of an old round brush.

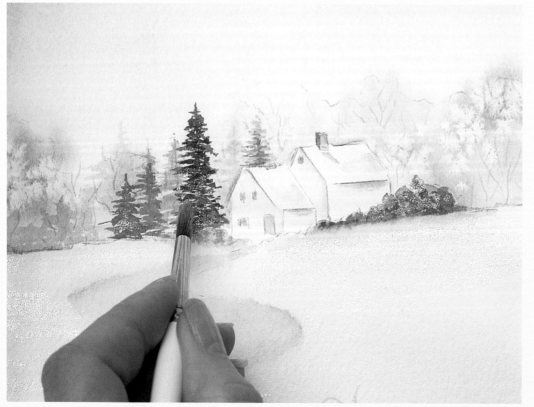

19 Dab more Iridescent Medium on the bushes and trees as desired.

COMPLETED WINTER LANDSCAPE

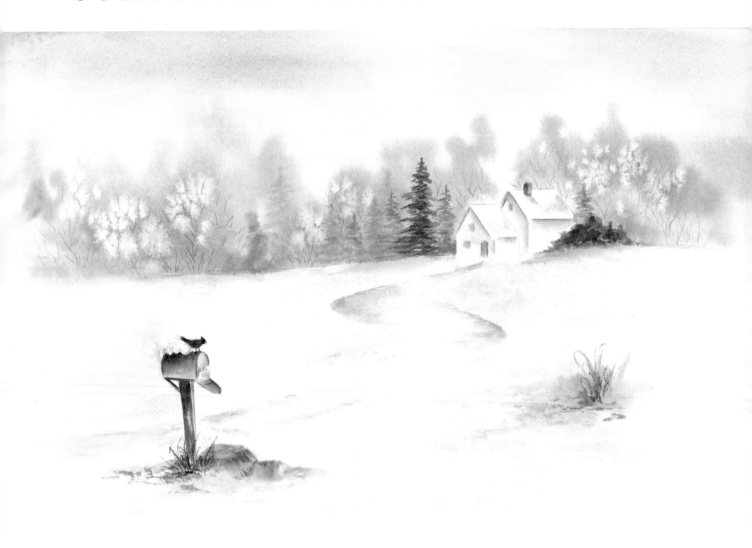

FRAMING TIP

*If the color tones in a painting lean to the cool side,
as they do in this winter landscape, silver-tone frames
usually work. If the color tones are warm, try gold.*

Gazebo in Autumn

Paint: WINSOR & NEWTON ARTISTS' WATER COLOURS

QUINACRIDONE
GOLD

BRIGHT RED

ALIZARIN CRIMSON

FRENCH
ULTRAMARINE

BURNT SIENNA

BURNT UMBER

You will also need the following colors, which are used in the color mixes below: New Gamboge, Raw Sienna, Antwerp Blue, Winsor Violet Dioxazine, Ivory Black.

The movie crew for Ah, Wilderness! *erected this gazebo on my town's common in the early 1900s.*

You'll use several techniques while painting this scene. Masking preserves the cupola and roof edge as you paint the sky and greenery. You'll use a sea sponge to dab on some of the foliage and a round brush to fill in the remaining leaves with a stutter stroke. Drybrushing is used to paint the tree trunks and fallen leaves. At the very end, you'll even practice a little liner brush "weed pulling."

Mixes

YELLOW GREEN*:
NEW GAMBOGE +
ANTWERP BLUE +
DOT OF BURNT UMBER

DV. YELLOW GREEN*:
NEW GAMBOGE +
ANTWERP BLUE +
DOT OF BURNT
UMBER

LV. BROWN:
BURNT SIENNA +
FRENCH
ULTRAMARINE

LV. WARM BROWN:
WINSOR VIOLET
DIOXAZINE +
RAW SIENNA

DV. BROWN:
BURNT UMBER +
IVORY BLACK

BLUE GRAY:
FRENCH
ULTRAMARINE +
BURNT SIENNA

RED ORANGE:
BURNT SIENNA +
ALIZARIN CRIMSON

*Yellow Green has less water than dv. Yellow Green.

M A T E R I A L S

Arches 140-lb. (300gsm) watercolor paper:
 cold-pressed
 10" x 11" (25.4cm x 27.9cm)

Royal Majestic Brushes

- no. 1 liner
- no. 4 round
- no. 6 round
- no. 8 round
- 1-inch (25mm) flat wash

Additional Supplies

- masking supplies: Winsor & Newton Art Masking Fluid, no. 2 round, soap, extra tub of water, rubber cement eraser
- small sea sponge

Pattern

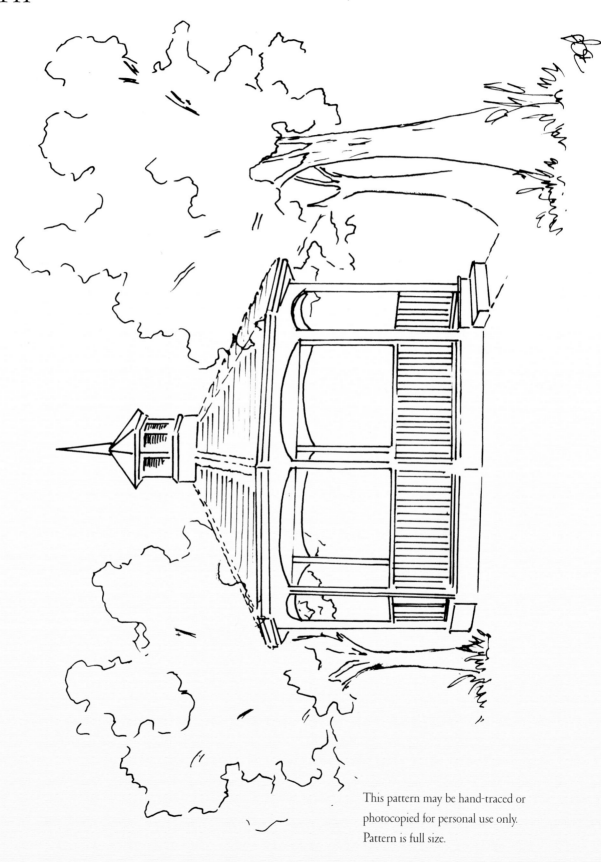

This pattern may be hand-traced or
photocopied for personal use only.
Pattern is full size.

Background

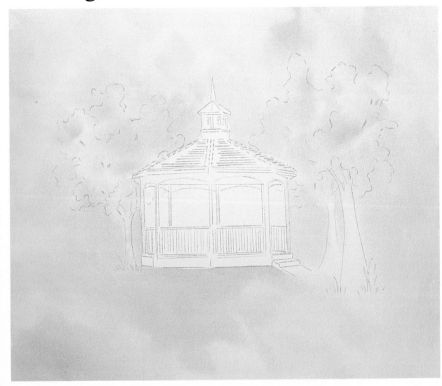

1 Tape down your watercolor paper and transfer the pattern (see pages 17-19).

Prepare a no. 2 round brush and masking fluid as described on page 31. Carefully apply the masking fluid on the gazebo spire, the cupola, along the roofline, on the far left and far right support posts and on the two back posts. (The masking appears light yellow in the photo.) Let the mask dry while you clean your brush. DO NOT clean your brush in the watercolor rinse water.

Dampen the background all around the gazebo with a 1-inch (25mm) flat brush. Hold your paper up to check for dry spots. Wait for an even sheen and no puddles. Still with the 1-inch (25mm) flat, apply French Ultramarine to the sky area, using slip-slap strokes. Add a little Yellow Green here and there, including under the foliage. Apply Alizarin Crimson at the bottom. Put in areas of Quinacridone Gold and Bright Red here and there.

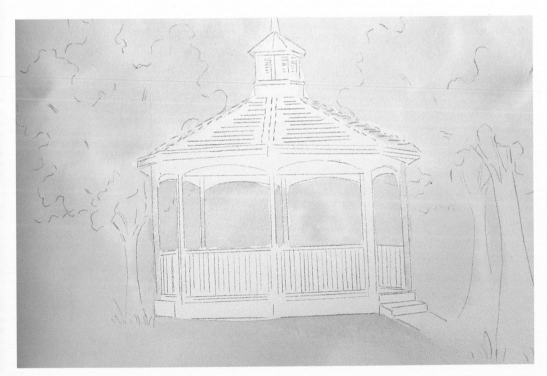

2 Dampen the area within the gazebo with a no. 8 round. You may only want to dampen two or three sections at a time. Here and there add a little Bright Red, Yellow Green and Quinacridone Gold.

Trees

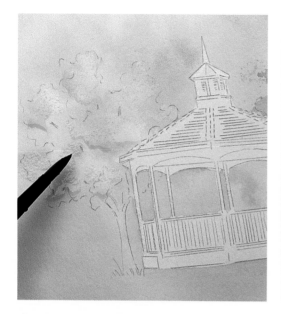

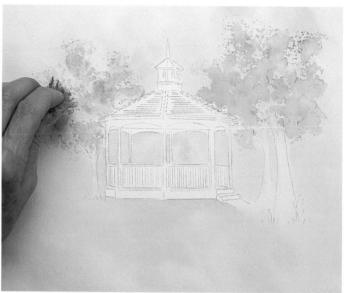

3 Dampen the treetops irregularly with a no. 8 round.

4 With a small piece of sea sponge, dab dv. Yellow Green in the tree leaf area. The irregular dampening gives different textures to the color. (See page 29 for more information about sponging.)

Hint

Always have a piece of 140-lb. (300gsm) watercolor paper handy for testing colors.

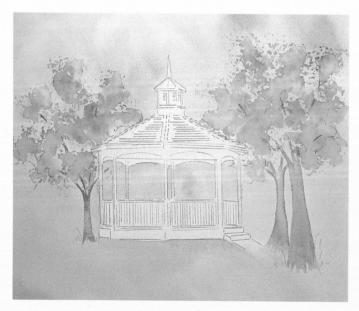

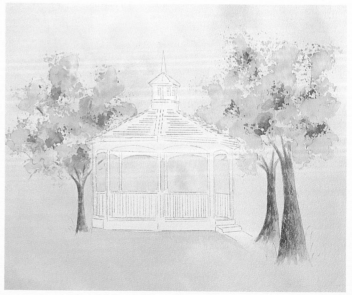

5 With lv. Brown on a no. 8 round, basecoat the tree trunks. Also, arbitrarily pull some branches up into the trees. Keep the bottom edges of the trees soft by rinsing your brush and feathering out the color.

6 Let the basecoat dry, and then drybrush more lv. Brown on the darker parts of the tree trunks. With a sea sponge, dab splotches of Burnt Sienna in the treetops. Soften the edges here and there with a damp no. 8 round.

Gazebo

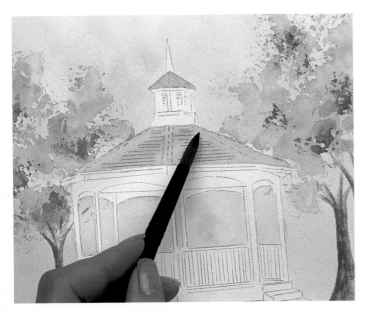

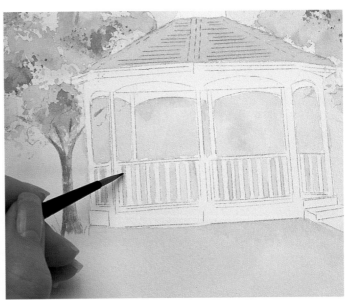

7 Remove all the mask with a rubber cement eraser. Basecoat the gazebo and cupola roof with lv. Warm Brown on a no. 8 round.

8 Load Yellow Green on a no. 4 round and carefully paint here and there between the gazebo rails. Do the same with Quinacridone Gold and Bright Red. Keep the colors light, patting excess color with a paper towel if necessary.

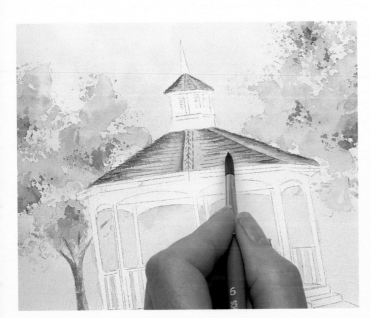

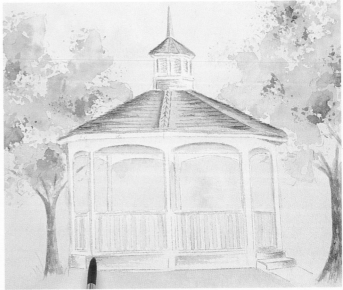

9 With dv. Brown on a no. 6 round, apply shading to the gazebo and cupola roof. To show the shingles, outline the diagonal lines. Then pick up a bit more paint and pull the horizontal shingle lines.

10 Load the no. 6 round with Blue Gray and apply shading, wet-on-dry, to all white areas of the gazebo. After applying color to one section, add a little water to the brush and soften the edges. The Blue Gray may tend to separate on your palette, so mix your paint puddle as necessary. Make sure that you shade each post and rail. When shading the long roofline, first dampen the paper slightly so the color will not dry before you have a chance to soften the edges.

Foliage and Foreground

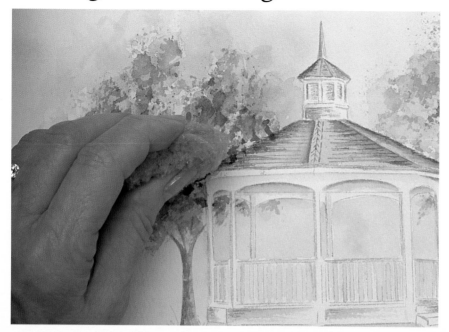

11 With a no. 8 round, dab Red Orange in "nervous stutter" strokes in and around the treetops. This stroke uses a start-and-stop motion instead of a long fluid one. Do the same with a little Quinacridone Gold.

With your sea sponge, dab on dv. Yellow Green, including a few leaves on and under the roof of the gazebo.

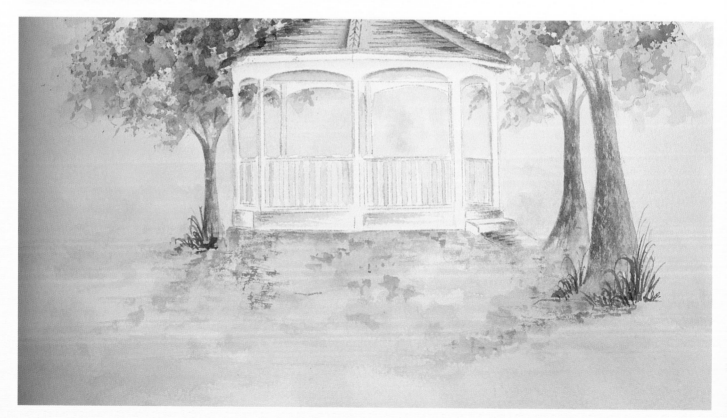

12 With a no. 8 round, add a wash of several colors in the foreground. Yellow Green, Quinacridone Gold and Red Orange have been applied. Soften with a damp 1-inch (25mm) flat if needed.

Paint the path at the foot of the steps with Burnt Umber, using your no. 6 round. Dab on a little Burnt Sienna here and there. Let dry.

Using the tip of the same brush, drybrush in some fallen leaves in Bright Red, Quinacridone Gold, Yellow Green and Red Orange.

Using a no. 1 liner, pull a few weeds around the trees in Burnt Sienna. Pull more weeds in dv. Brown. Always pull weeds from the ground up.

COMPLETED GAZEBO

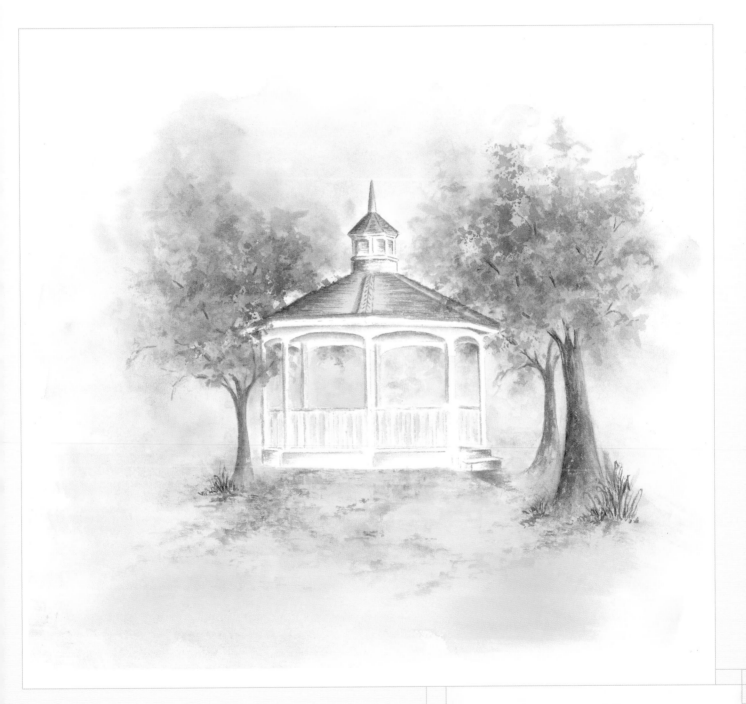

FRAMING TIP

Never let glass rest directly on top of your watercolor. Use a spacer or a mat.

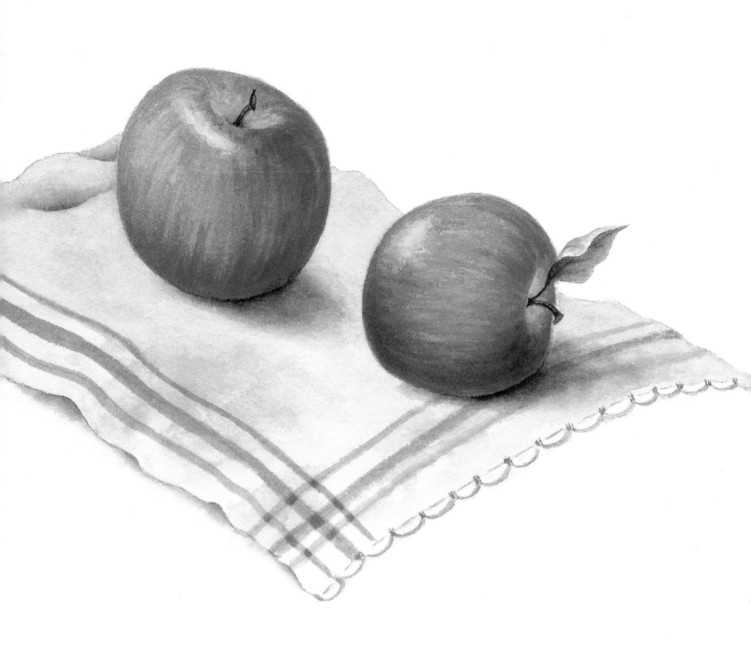

Apples on Tea Cloth

Paint: WINSOR & NEWTON ARTISTS' WATER COLOURS

WINSOR ORANGE

BRIGHT RED

WINSOR RED

ALIZARIN CRIMSON

NEUTRAL TINT

You will also need the following colors, which are used in the color mixes: New Gamboge, Burnt Umber, Hooker's Green, Antwerp Blue, Ivory Black.

I found these apples in my backyard and loved their color. My challenge was to find a way to paint them realistically with a technique simple enough for any painter. I accomplished my goal by applying multiple layers of shading and streaking that build the apples' dimension. Placing them on a vintage tea towel allowed me to show off their beauty.

Mixes

LIGHT BROWN:
BURNT UMBER +
IVORY BLACK

MEDIUM GREEN:
HOOKER'S GREEN +
BURNT UMBER

LIGHT YELLOW
GREEN:
NEW GAMBOGE +
ANTWERP BLUE

M A T E R I A L S

Surface

Arches 140-lb. (300gsm) watercolor paper:
 cold-pressed
 8" x 10" (20.3cm x 25.4cm)

Royal Majestic Brushes

• no. 4 round
• no. 6 round
• no. 8 round

Additional Supplies

• masking supplies: Winsor & Newton Art Masking Fluid,
 no. 2 round, soap, extra tub of water, rubber cement eraser
• craft knife

Pattern

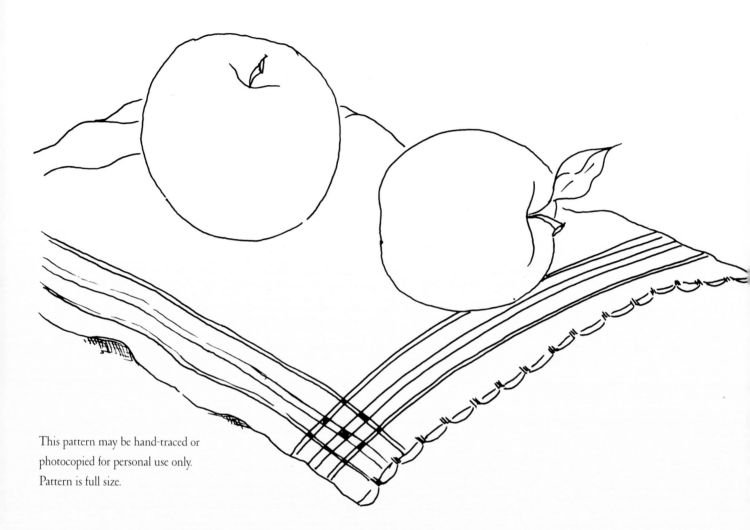

This pattern may be hand-traced or
photocopied for personal use only.
Pattern is full size.

Tea Cloth

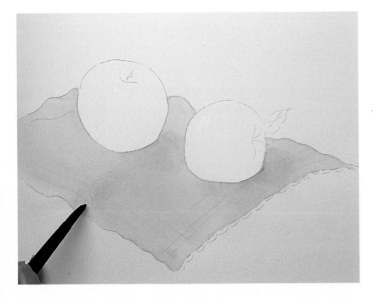

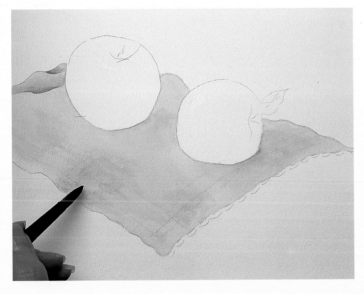

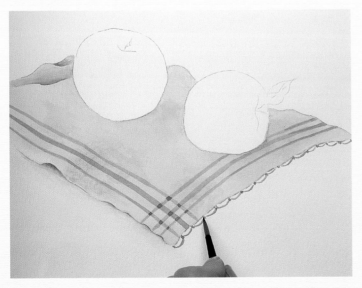

1 Tape down your watercolor paper and transfer the pattern (see pages 17-19). Mask the highlighted area of the apple as explained on page 31. Wet down the tea cloth area. Then apply a light wash of Light Brown with the no. 8 round. While the cloth is still damp, apply the light shading. As the paper sets up, use the same color to add the first layer of darker shading. Let dry.

2 Apply more of the same color in the darker shaded areas behind the left apple, wet-on-dry. Rinse the brush and soften outward. Then with the same color, drybrush a bit more shading in the foreground area with the side of the brush tip, adding a bit of texture and the semblance of a light rumpling.

3 On your palette, pull out a bit of Light Brown + a bit of Ivory Black. Then with the no. 8 round, paint in an area of shading under the left side of the cloth and soften.

With the no. 6 round, pull in the cloth stripes with Medium Green. Repaint the portions of the stripes where they cross each other. Then paint the right-side scallop "smiles" with the same color. When the smiles are done, paint the connecting lines between the smiles with the same color on a no. 4 round.

Apple Basecoating

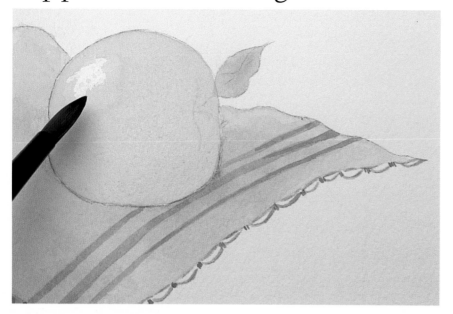

4 With Medium Green on a no. 6 round, basecoat the leaf. Now you're ready to start the apples. With a no. 8 round, apply a basecoat of Light Yellow Green, wet-on-wet. Let this dry, and then dampen the first apple again. Starting at the outside edge, apply the same color, spiraling inward to just outside the masked highlight area. Let dry. You will continue to build concentric layers of paint so that the colors intensify as they move away from the highlight.

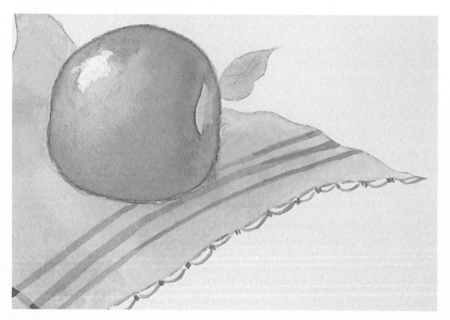

Hint

When painting the apples, finish applying a color on one apple and then repeat for the second apple. This allows the apples to dry between colors.

5 These directions will proceed as if you are painting only one apple, although actually you will be alternating between the two.

After wetting down the apple, glaze Winsor Orange with a no. 8 round, again starting at the outside edge and working in, this time stopping a little further yet from the highlighted area. Let dry.

Wet down the apple except in the stem dimple. Glaze Bright Red, starting just under the dimple area and again work down, stopping a little further back than you did with the Winsor Orange. Let dry.

Wet down the same area you did for Bright Red. Then glaze Winsor Red, stopping a little further back than you did for Bright Red. Let dry. Go back and soften the red into the area opposite the stem.

Apple Streaking

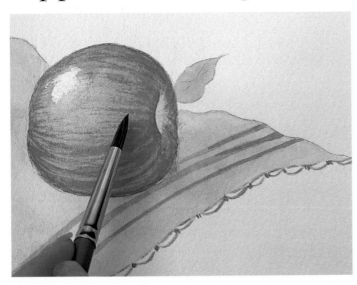

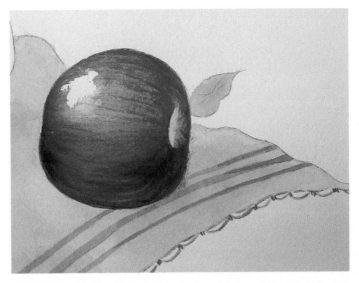

6 With a no. 6 round, draw streaks of Winsor Red, wet-on-dry, following the apple's contour. Pull a few streaks into the outer highlight area. Let dry.

7 Using the same method as in the last step, apply streaks of Alizarin Crimson. Repeat in the darker area. With Alizarin Crimson still in your brush, pick up a little Neutral Tint and pull streaks in the darkest areas.

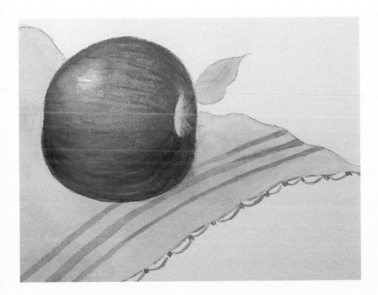

8 Erase the mask with a rubber cement eraser. Working in and around the highlight with a no. 6 round, streak in a little Light Yellow Green. With a damp brush, soften the hard edge around the highlight.

Hint

Practice streaking before using it on your apples so you'll understand how to use direction and pressure.

Leaf, Stem and Shadow

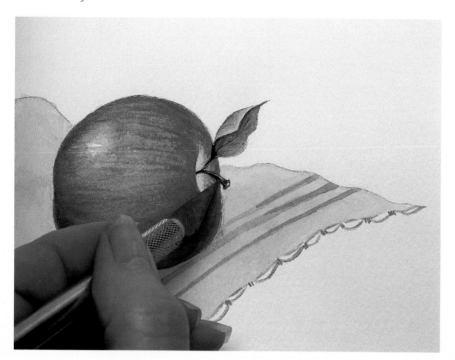

9 Dampen the flipped portion of the leaf with a no. 6 round. Apply Medium Green to the outer edge and soften. Let dry. Then dampen the darker part of the leaf underside, apply Medium Green shading and soften.

By this time, the Light Brown you used on the tea towel should have dried on your palette, creating a darker value. Load a bit on a no. 4 round and paint the apple stem. Then pick up some Medium Green to connect the leaf to the stem and pull the leaf vein. With a craft knife, scratch a thin stem highlight.

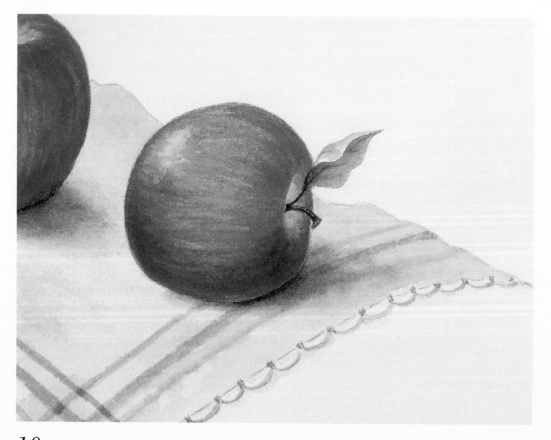

10 Dampen the apple shadow area. With Neutral Tint on a no. 6 round, apply paint under the apple and soften the shadow area out.

COMPLETED APPLES ON TEA CLOTH

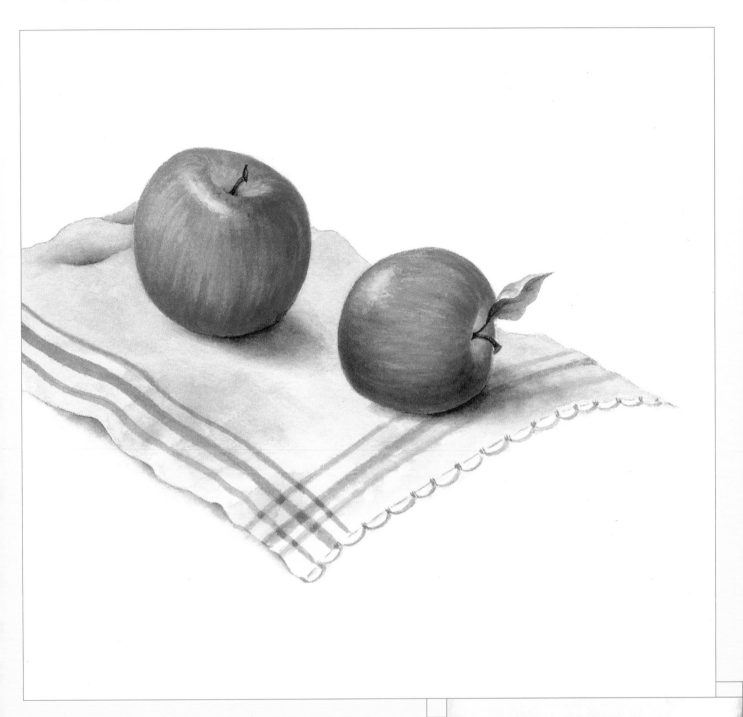

FRAMING TIP

Picture frame glass is clearer than regular glass, which has a tinge of green.

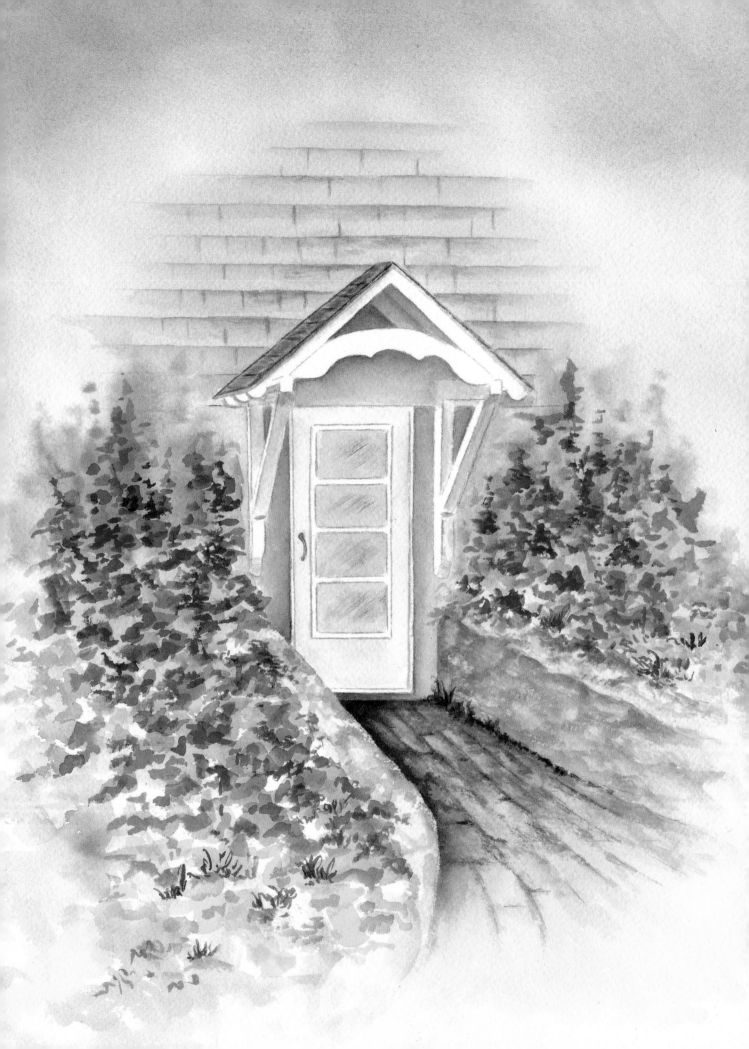

Garden Pathway

Paint: WINSOR & NEWTON ARTISTS' WATER COLOURS

NEW GAMBOGE

BRIGHT RED

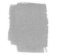
WINSOR RED

ALIZARIN CRIMSON

BURNT SIENNA

COBALT BLUE

WINSOR VIOLET
DIOXAZINE

You will also need these colors, which are used in the mixes below: French Ultramarine, Hooker's Green, Burnt Umber, Ivory Black.

Mixes

MEDIUM BURNT UMBER:
BURNT UMBER +
IVORY BLACK

LIGHT BRICK:
BURNT SIENNA +
WINSOR RED

WARM GRAY*:
COBALT BLUE +
BURNT SIENNA

COOL GRAY*:
COBALT BLUE +
BURNT SIENNA

GOLD:
NEW GAMBOGE +
BURNT UMBER

GREEN:
HOOKER'S GREEN +
BURNT UMBER +
FRENCH
ULTRAMARINE

*Cool Gray has more Cobalt Blue than Warm Gray.

Come into Monet's Garden— otherwise known as the entrance to my studio, The Sellar Shop. This project teaches you the technique of "suggesting" soft flowers rather than actually painting individual petals. Sometimes less is more. The build-up of values is what creates interest. Notice that the cooler colors are in the back of the garden and the warmer ones in front.

Developing a brick path and wall in this simple manner gives you the knowledge to design your own pathway—maybe to a garden gate. Let your imagination go. You may be surprised where it takes you.

Materials and Pattern

Surface
Arches 140-lb. (300gsm) watercolor paper:
 cold-pressed
 12" x 9" (30.5cm x 22.9cm)

Royal Majestic Brushes
•no. 1 liner
•no. 4 round
•no. 6 round
•no. 8 round
•1-inch (25mm) flat wash

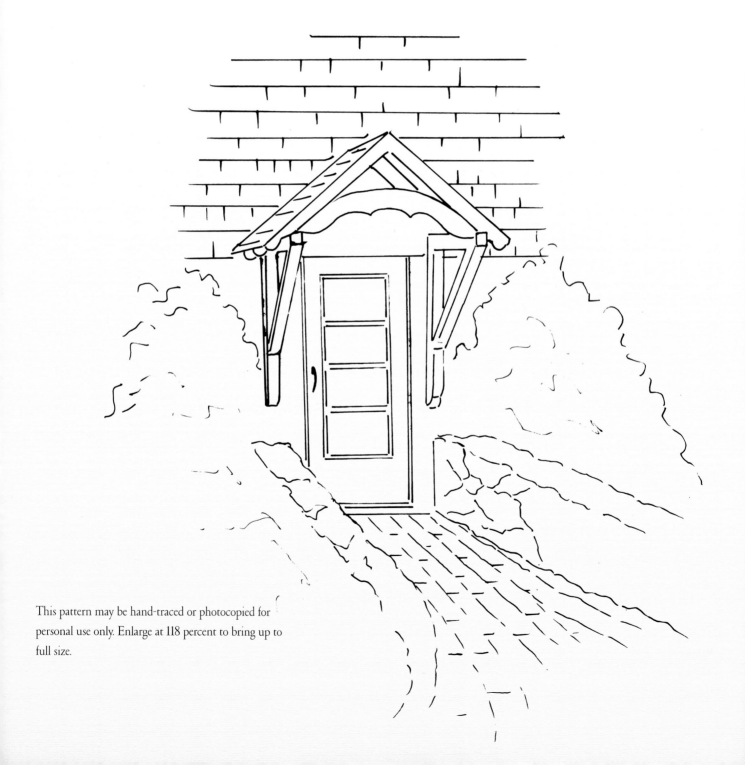

This pattern may be hand-traced or photocopied for
personal use only. Enlarge at 118 percent to bring up to
full size.

Background, Siding and Wall

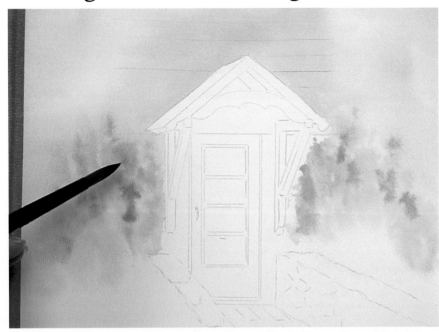

1 Tape down your watercolor paper and transfer the pattern (see pages 17-19). With the 1-inch (25mm) flat, wet down the area around the door down to the stone wall. Using the same brush, slip-slap in the sky with Cobalt Blue.

 Clean your brush. If you've already mixed Warm Gray on your palette, stir it with your brush, because this mix tends to granulate (see page 11). Then brush in a basecoat for the house siding, avoiding the doorway roof.

 With a light value of Green on a no. 8 round, dab in some greenery.

 Rinse your brush and then dab in light values of Winsor Violet Dioxazine and Cobalt Blue. Apply these colors as if you are forming tall flowers, such as foxgloves or delphinium. Let dry.

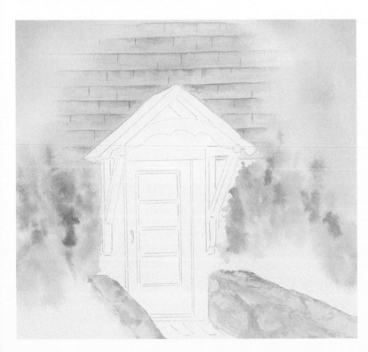

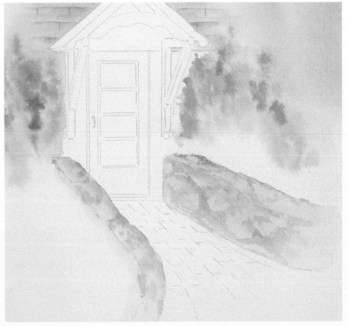

2 With a light value of Warm Gray on the no. 8 round, pull shading lines under the house-siding shingles. Then dampen the brush and soften. Go through this process one small section at a time.

 Using the same brush, drybrush in a whisper of Burnt Sienna here and there.

 Rinse and paint in vertical lines of Warm Gray here and there to suggest shingles. Some lines will pull up from the horizontal lines and some will pull down.

3 Wet down the stone wall and, with the no. 8 round, apply a light-value wash of Warm Gray. While the wall is still damp, dab on shading of the same color.

Doorway

4 Basecoat the area around the door with Cool Gray on a no. 8 round. Rinse your brush and basecoat the windows in a light value of Cobalt Blue. Let dry.

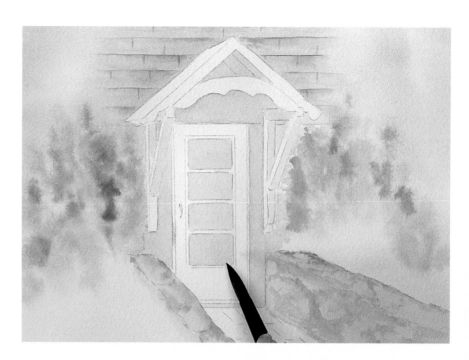

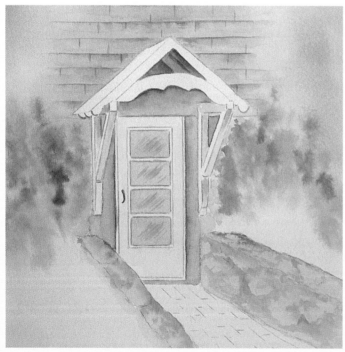

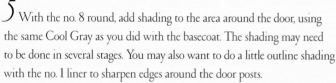

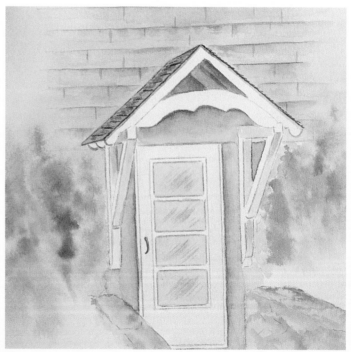

5 With the no. 8 round, add shading to the area around the door, using the same Cool Gray as you did with the basecoat. The shading may need to be done in several stages. You may also want to do a little outline shading with the no. 1 liner to sharpen edges around the door posts.

Rinse the brush and apply streaks of Cobalt Blue reflection lines to the windows.

Again rinse the no. 1 liner, and then apply a light "dirty water" value of Cool Gray just to the door to soften the white of the paper. Let dry. Using the same color, outline the windows and door details except for the handle.

Still using the no. 1 liner, basecoat the door handle in Gold and let dry. Then add a line of Medium Burnt Umber to the left side.

6 With the no. 6 round, apply a wash of Medium Burnt Umber to the doorway's left roof. As soon as this dries, apply shading with a darker value of the Medium Burnt Umber. While that sets up, draw a line down the underside of the right roofline and lightly add short shingle lines. Now outline around the trapezoid forming the doorway's left roof. Then, using a no. 4 round, pull the left roof shingle lines. Let everything dry, and then apply a Cool Gray shading line under the Medium Burnt Umber lines against the white wood. Do not soften.

Wall and Pathway

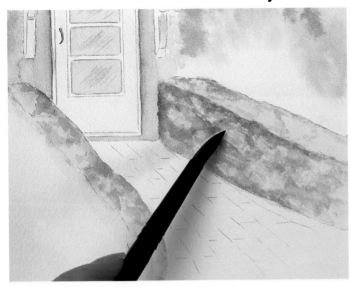

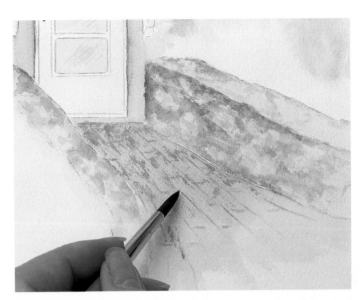

7 With the no. 8 round, dab Warm Gray here and there on both stone walls. Dab in a little Green and a little Burnt Sienna. You can experiment with other colors here, such as Cool Gray. What is most important is that the side of the right wall is darker than the top of the right wall.

8 With Light Brick on a no. 6 round, basecoat the pathway, wet-on-wet. Let dry. Drybrush more Light Brick for shading, dabbing here and there. Lightly pull in some reference brick lines, which you will use to help you place the moss.

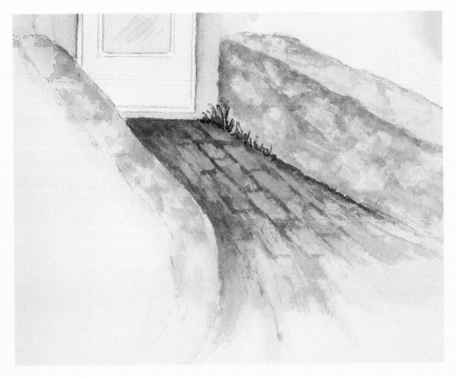

9 With the tip of a no. 6 round, drybrush Green here and there between the bricks and against the wall. If the brick texture seems too rough, add another layer of Light Brick. With a no. 4 round, pull a few Green grass blades next to the far wall, near the door.

Flowers

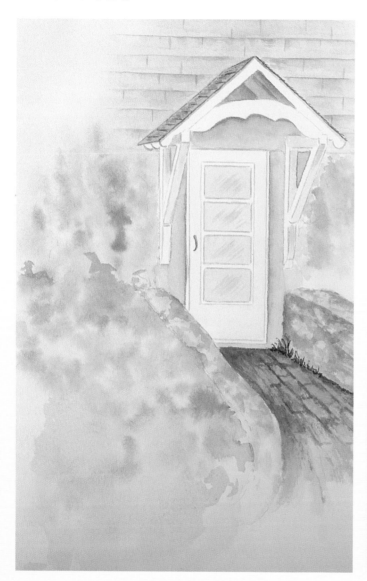

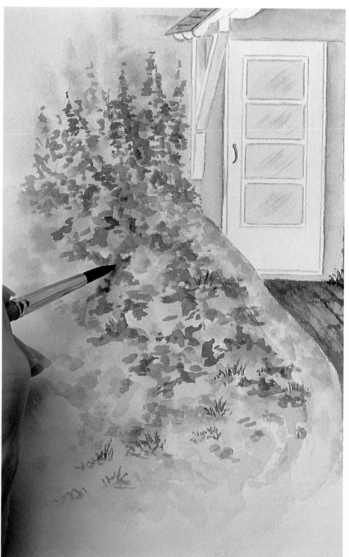

10 Wet down the flower area with a 1-inch (25mm) flat. As you apply the following colors, leave some white paper showing. Dab here and there with a light value of Green on a no. 8 round, getting a little on the wall top. Then dab in light values of Cobalt Blue, Winsor Violet Dioxazine, Winsor Red, New Gamboge, Alizarin Crimson and Bright Red. Here you see these colors have been added on the left, but not yet on the right. Let dry.

11 Now you will build color and shape on the flowers by dabbing darker values to each of the colors without completely covering the lighter values. Use a no. 6 round. Remember to leave some white paper showing. Give the flowers in the back a tall cone shape like delphiniums, hollyhocks or foxgloves. Keep the colors softer on the outside edges and warmer in the foreground.

COMPLETED GARDEN PATHWAY

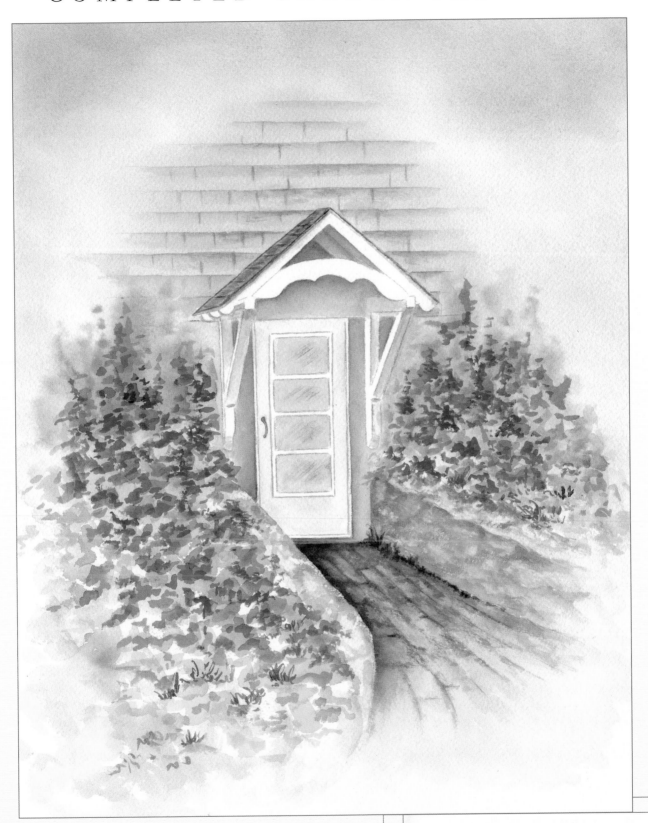

FRAMING TIP

Plexiglas will help preserve your picture better than glass.
Just be sure you use a Plexiglas cleaner.

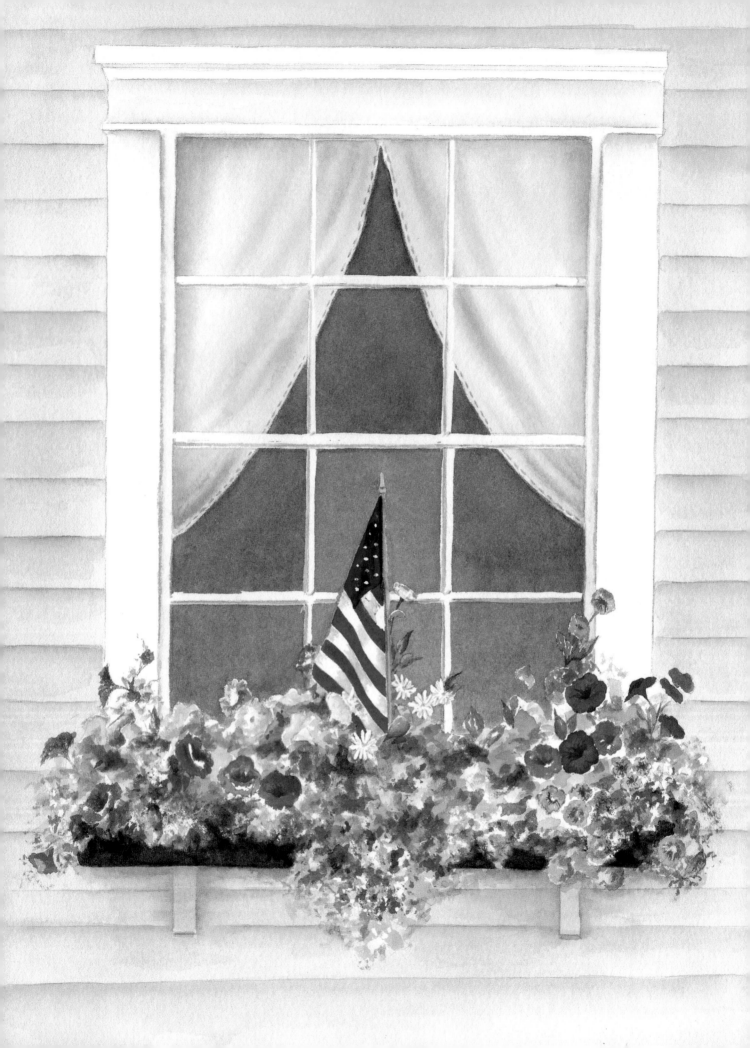

Nantucket Window Box

Paint: WINSOR & NEWTON ARTISTS' WATER COLOURS

NEW GAMBOGE

ROSE DORÉ

LV. ALIZARIN CRIMSON*

DV. ALIZARIN CRIMSON*

PAYNE'S GRAY

You will also need these colors, which are used in the mixes below: Burnt Sienna, Cobalt Blue, Burnt Umber, Ivory Black, French Ultramarine, Winsor Violet Dioxazine, Raw Sienna, Aureolin, Hooker's Green.

Mixes

LV. WARM GRAY*:
COBALT BLUE +
BURNT SIENNA

DV. WARM GRAY*:
COBALT BLUE +
BURNT SIENNA

COOL GRAY**:
COBALT BLUE +
BURNT SIENNA

DARK BROWN:
BURNT UMBER +
IVORY BLACK

DARK BLUE:
FRENCH ULTRAMARINE
+ IVORY BLACK

GOLD:
NEW GAMBOGE +
BURNT UMBER

DULL RED:
ALIZARIN CRIMSON +
IVORY BLACK

SOFT VIOLET:
WINSOR VIOLET
DIOXAZINE + RAW
SIENNA

LV. YELLOW GREEN:
AUREOLIN +
COBALT BLUE

MEDIUM GREEN:
NEW GAMBOGE +
COBALT BLUE

DARK BLUE GREEN:
HOOKER'S GREEN +
IVORY BLACK +
BURNT UMBER

*The light values of these colors have more water added than the dark values.

**Cool Gray has more Cobalt Blue than either of the Warm Grays.

I saw this window while vacationing in Nantucket. It's common to see some symbol of patriotism on American houses these days. A few alternate flag choices are on page 118.

The cool color of the window glass lends a cloudy-day feeling and makes a good backdrop for the flag and flowers. Using lightly thinned masking fluid gives you a better chance of achieving nice thin mullions. If you find unwanted color after the masking is erased, you can make corrections with a craft knife. You'll use a loose approach to form the greenery and background flowers. Here color value is more important than perfect painting. Line work cleans up edges on the daisies and the flag, and creates the shadowed edge on the mullions. Curtain stitching adds whimsy.

Materials and Patterns

Surface

Arches 140-lb. (300gsm) watercolor paper:
 cold-pressed
 12" x 9½" (30.5cm x 24.1cm)

Royal Majestic Brushes

- no. 1 liner
- no. 4 round
- no. 6 round
- no. 8 round
- 1-inch (25mm) flat wash

Additional Supplies

- masking supplies: Winsor & Newton Art Masking Fluid, no. 2 round, soap, extra tub of water, rubber cement eraser
- craft knife (for touch-ups)
- small sea sponge

Alternate Flag Patterns

AUSTRALIA

Blue - French Ultramarine
Red - Bright Red + Alizarin Crimson

CANADA

Red - Bright Red + Alizarin Crimson

UNITED KINGDOM

Blue - French Ultramarine
Red - Bright Red + Alizarin Crimson

These patterns may be hand-traced or photocopied for personal use only. Enlarge at 118 percent to bring up to full size.

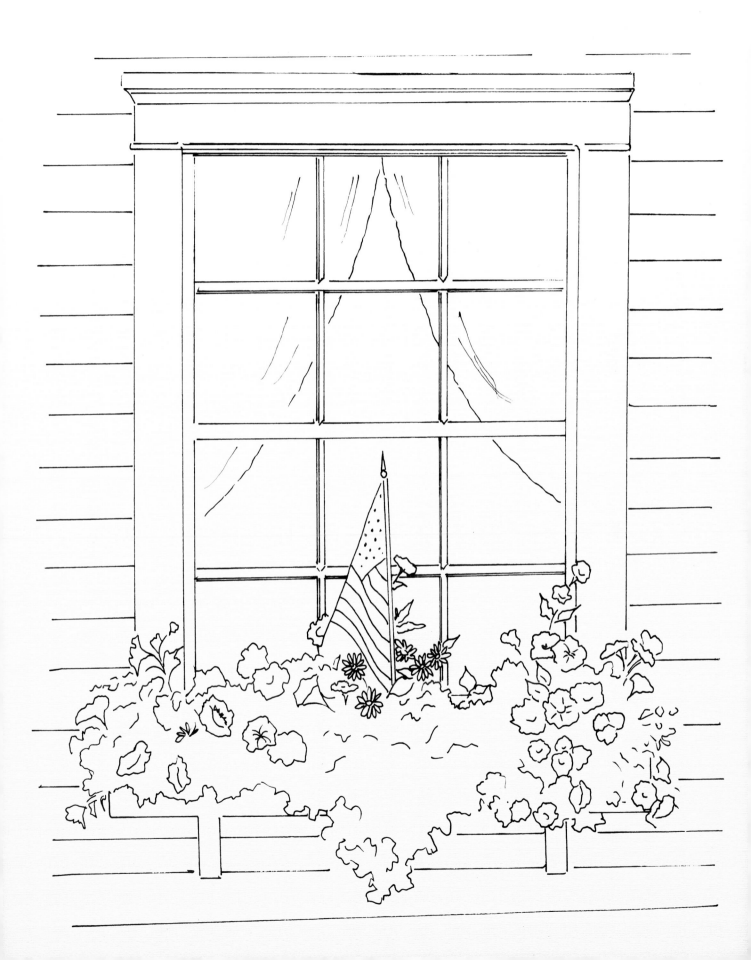

Siding and Window

1 Tape down your watercolor paper and transfer the pattern (see pages 17-19). Prepare a no. 2 round brush and masking fluid as explained on page 31. Add a drop or two of water to thin the fluid and mix well. Mask the window mullions, flagpole, flag stars, the flowers marked on the pattern, and the leaves in the window area to the right of the flagpole. (The masking appears yellow in the photo.)

With a 1-inch (25mm) flat, wet down the wood siding and window box supports. Then lay down a basecoat of lv. Warm Gray. Let Dry.

Changing to a no. 8 round, use the same color, wet-on-dry, to shade beneath the wood siding lines. Soften the color downwards. You can further soften with a cotton swab, if necessary. Shade one board at a time, alternating rows, as you see here. Then go back and finish the unshaded rows. Allowing the alternate boards time to dry prevents unwanted color flow, keeping the boards distinct.

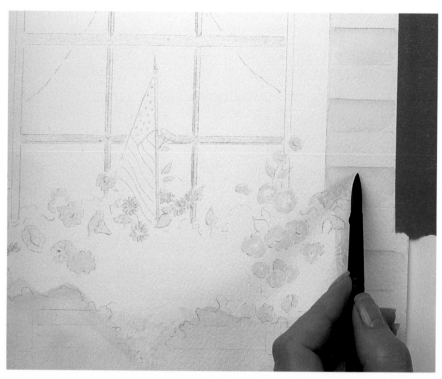

2 Paint the curtains one side at a time, wet-on-wet, using Payne's Gray on a no. 8 round. Then create shading with a light value of Payne's Gray. Let dry. With a no. 1 liner, paint the curtain stitching with Payne's Gray at an ink-like consistency.

Do the window background wet-on-wet, half at a time. Apply Cool Gray with the no. 8 round. Once the background is dry, you may want to add a second coat to achieve your preferred degree of darkness.

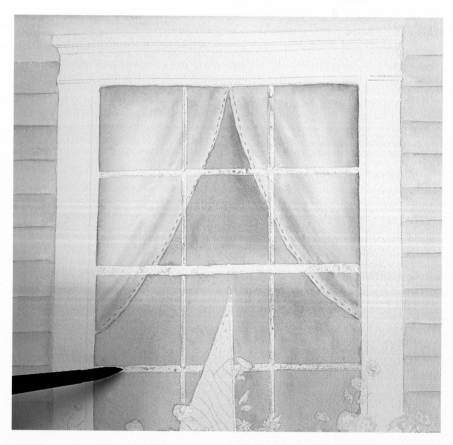

Window

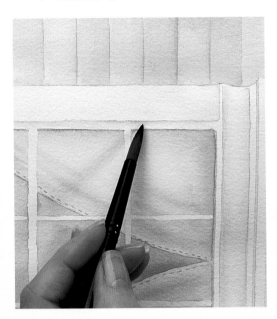

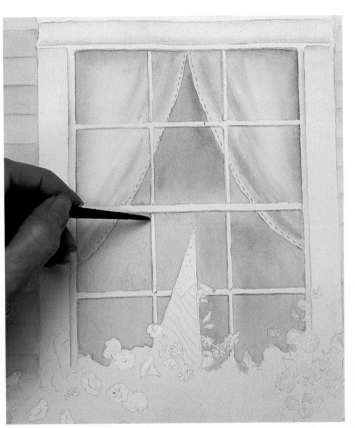

3 When the window and curtains are completely dry, remove the mask on the mullions with a rubber cement eraser. With lv. Warm Gray on a no. 8 round, apply shading, wet-on-wet, to the outside window molding. Start close to the pattern lines and soften outward. For the side moldings, turn the painting board so that when you pull the line of color, it will flow downward to create the softer shading.

4 Next you will paint mullion shading with either a lv. Warm Gray or dv. Warm Gray, depending on which works best with your background. Mix your gray to an ink-like consistency, and using a no. 4 round, paint the mullion shading, wet-on-dry. First shade the vertical mullions, not crossing the horizontal mullions, but putting in a short line at the top of the horizontal mullions where they cross the vertical. Then paint the horizontal mullion shading lines. Do not cross the top and bottom vertical mullions, but the middle horizontal mullion shading goes all the way across.

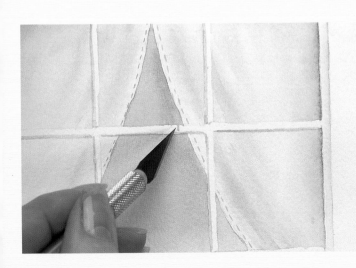

5 If you have stray paint on the mullions, you can scrape it off lightly with a craft knife. Scratching off the paint will damage the paper, so you will not be able to paint in that area later.

Window Box, Flowers and Flag

Hint

When building colors, such as with flowers, always start with the lighter values and never completely cover the lighter colors with the darker ones.

6 With lv. Warm Gray on a no. 8 round, add shading around the window box supports. Let dry. Then paint the window box with a rich consistency of Dark Brown. Let dry and then apply extra Dark Brown shading to achieve the desired intensity of a cast shadow from the flowers.

7 With a no. 8 round, irregularly wet the flower area in "nervous puddles." Some of the dry spaces will be left white. To paint the flowers, you will dab here and there with the tip of the brush, building values from light to dark. Be sure to get color around the daisies so they will stand out beneath the flag.

 Start with lv. Yellow Green. Rinse the brush and then dab in lv. Alizarin Crimson. Let dry.

8 Paint the blue part of the flag in Dark Blue with a no. 6 round. Let dry. Rinse the brush and, with a light value of Payne's Gray, add shading to the white stripes, wet-on-wet.

Flowers and Flag

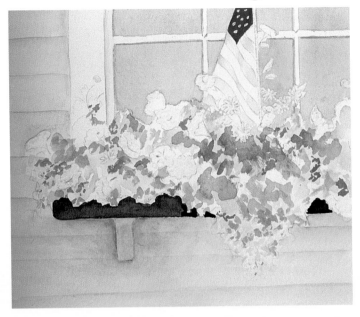

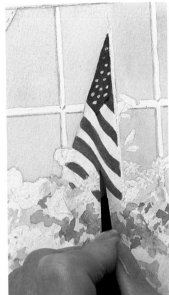

10 With a no. 4 round, paint the red flag stripes with dv. Alizarin Crimson. As you continue painting, be careful not to touch the intense red or blue of the flag. They will run no matter how dry they seem.

9 Returning to the flower area, which should be dry, dab Medium Green with the tip of the no. 8 round. Rinse the brush and dab in a darker value to the Alizarin Crimson flowers. When you finish dabbing colors, let dry.

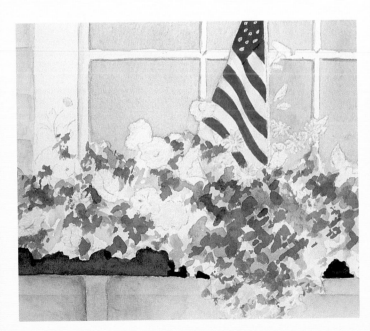

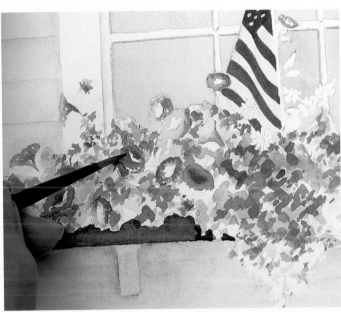

11 Make sure the flower area is dry. Then paint irregular shapes of Dark Blue Green with the no. 8 round. Let dry completely.

12 Erase the mask in the flower area. You may need to pencil the flowers back in. With a no. 4 round, base some petunias with a light value of Soft Violet and some with a light value of Dull Red. Then add darker values to form the petunia shapes. Flowers on the outside edges should be less intense, so that the more intense ones toward the center will create a focal point.

Jumping around from one flower to the next allows the basecoat to set before you apply the darker value. This is the effect you see here. If you prefer a softer effect, add the darker value before the lighter value sets up.

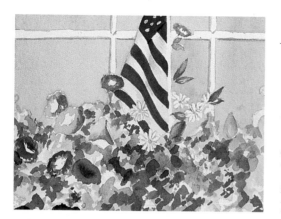

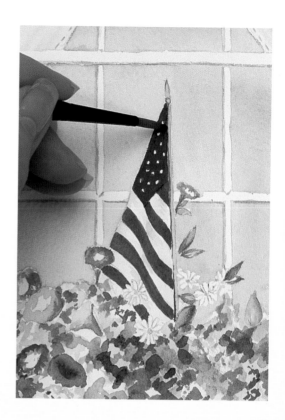

13 (left) Using the tip of the no. 4 round, lightly outline the daisy petals with a light value of Payne's Gray. In the center of the daisies, add a touch of New Gamboge. Using the same brush, base the daisy leaves in lv. Yellow Green. While they're still wet, add shading in Medium Green or Dark Blue Green.

14 (right) Erase the mask from the flagpole and the flag stars. Paint the flagpole, including the tip, with Gold on a no. 4 round. With the same brush, add a line of Dark Brown between the pole and the flag. Also add defining lines to the pole tip.

Hint

Remember that using more than one value on each flower is more important than the specific colors used.

15 With a no. 8 round, add a thin wash of Rose Doré over the red and pink flowers. This transparent color will brighten without influencing the values. With the Dark Blue Green, darken the greens hanging over the flower box.

16 For the final building of green values, use a small sea sponge to dab on a few touches of Dark Blue Green, especially on the outside edges. Let dry and then dab in more color all over with the no. 6 round. Again, let dry. With the no. 8 round, do a final wash of New Gamboge to warm up the greenery.

COMPLETED WINDOW BOX SCENE

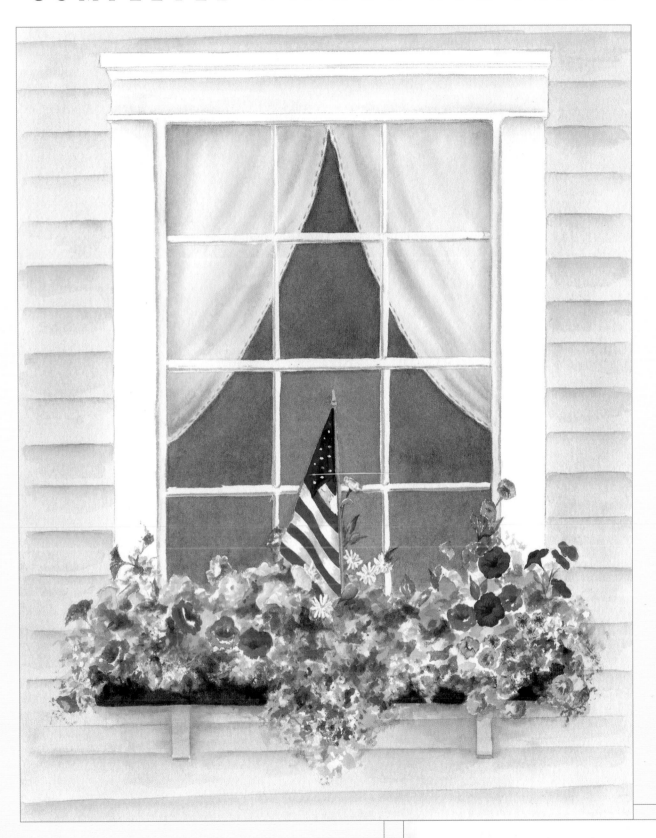

FRAMING TIP

Double-matting means using two mats, one with a slightly larger opening than the other. When the mats are two shades of white, they add a tone-on-tone interest.

Resources

BRUSHES

ROYAL BRUSH MANUFACTURING (U.S.)
6707 Broadway
Merrillville, IN 46410
E-mail: customerservice@royalbrush.com
www.royalbrush.com

ROYAL BRUSH MANUFACTURING LTD. (U.K.)
Block 3 Unit 3 Wednesbury Trading Estate
Bilston Road
Wednesbury
West Midlands WS10 7JN
E-mail: uk@royalbrush.com
www.royalbrush.com

PAINTS AND MEDIUMS

COLART AMERICAS (WINSOR & NEWTON)
11 Constitution Avenue
Piscataway, NJ 08855-1396
Phone: 732-562-0770
www.winsornewton.com

DECOART
P.O. Box 360
Stanford, KY 40484
Phone: 800-257-8278
www.decoart.com

GENERAL SUPPLIES

Wax-free transfer paper
SARAL PAPER CORPORATION
400 East 55th Street, Suite 14C
New York, NY 10022
Phone: 212-223-3322
Fax: 212-223-8111
www.saralpaper.com

Scotch Safe-Release Painters' Masking Tape
3M
Phone: 1-888-3M HELPS
www.3m.com

CANADIAN RETAILERS

CRAFTS CANADA
2745 29th Street Northeast
Calgary, AL, T1Y 7B5

FOLK ART ENTERPRISES
P.O. Box 1088
Ridgetown, ON, N0P 2C0
Tel: 888-214-0062

MACPHERSON CRAFT
WHOLESALE
83 Queen Street East
P.O. Box 1870
St. Mary's, ON, N4X 1C2
Tel: 519-284-1741

MAUREEN MCNAUGHTON
ENTERPRISES INC.
RR #2
Belwood, ON, N0B 1J0
Tel: 519-843-5648
Fax: 519-843-6022
E-mail: maureen.mcnaughton.ent.inc@
 sympatico.ca
www.maureenmcnaughton.com

MERCURY ART &
CRAFT SUPERSHOP
332 Wellington St.
London, ON, N6C 4P7
Tel: 519-434-1636

TOWN & COUNTRY
FOLK ART SUPPLIES
93 Green Lane
Thornhill, ON, L3T 6K6
Tel: 905-882-0199

U.K. RETAILERS

ART EXPRESS
Design House
Sizers Court
Yeadon LS19 6DP
Tel: 0800 731 4185
www.artexpress.co.uk

ATLANTIS ART MATERIALS
146 Brick Lane
London E1 6RU
Tel: 020 7377 8855

CRAFTS WORLD (head office)
No. 8 North Street, Guildford
Surrey GU1 4AF
Tel: 07000 757070

GREEN & STONE
259 King's Road
London SW3 5EL
Tel: 020 7352 0837
E-mail: greenandstone@
 enterprise.net

HOBBY CRAFTS (head office)
River Court
Southern Sector
Bournemouth
International Airport
Christchurch
Dorset BH23 6SE
Tel: 0800 272387

HOMECRAFTS DIRECT
P.O. Box 38
Leicester LE1 9BU
Tel: 0116 251 3139

Index

THE BEST IN
Watercolor Instruction

COMES FROM NORTH LIGHT BOOKS!

Decorative painters and beginning artists alike will be introduced to watercolor materials and basic painting techniques illustrated through detailed mini-demos in this concise, easy to understand guide. Well-known watercolor designer Paul Brent will lead you through 13 complete step-by-step projects to create beautiful works of flowers, fruits, bees, and butterflies that you'll be proud to showcase.

ISBN 1-58180-398-2, paperback, 128 pages, #32470-K

Charles Reid is one of watercolor's best-loved teachers, a master painter whose signature style captures bright floral still-lifes with a loose spontaneity that adds immeasurably to the whole composition. In this book, Reid provides the instruction and advice you need to paint fruits, vegetables and flowers that glow.

Special "assignments" and step-by-step exercises help you master techniques for wild daffodils, roses, mums, sunflowers, lilacs, tomatoes, avocados, oranges, strawberries and more!

1-58180-027-4, hardcover, 144 pages, #31671-K

No matter how little free time you have available for painting, this book gives you the confidence and skills to make the most of every second. Learn how to create simple finished paintings within sixty minutes, then attack more complex images by breaking them down into a series of "bite-sized" one-hour sessions. 12 step-by-step demos make learning easy and fun. You'll find that whatever time you have to paint is really all the time you need!

1-58180-035-5, paperback, 128 pages, #31800-K

Nature paintings are most compelling when juxtaposing carefully textured birds and flowers with soft, evocative backgrounds. Painting such realistic, atmospheric watercolors is easy when artist Susan D. Bourdet takes you under her wing. She'll introduce you to the basics of nature painting, then illuminate the finer points from start to finish, providing invaluable advice and mini-demos throughout.

ISBN 1-58180-164-5, hardcover, 128 pages, #31914-K

FIND THESE AND OTHER FINE NORTH LIGHT BOOKS AT YOUR LOCAL BOOK RETAILER OR ART SUPPLY STORE.